W9-AZS-843

H O N O R   D A N C E

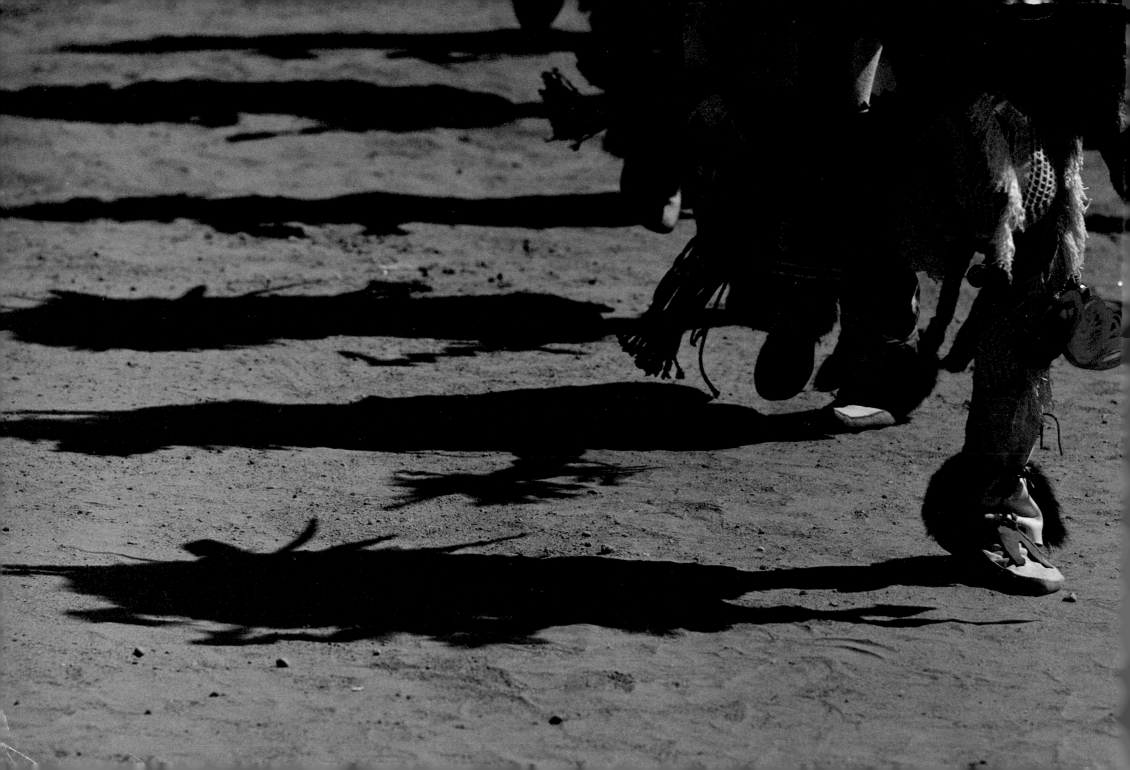

# HONOR DANCE

NATIVE AMERICAN PHOTOGRAPHS

## JOHN RUNNING

FOREWORD: WILLIAM ALBERT ALLARD

RENO: UNIVERSITY OF NEVADA PRESS: 1985

Original photographic prints from *Honor Dance* are available from:
The Bennett/Running Gallery
Post Office Box 1237
Flagstaff, Arizona 86002
(602) 774-2923

Composed and printed in the United States of America

Library of Congress Cataloging-in-Publication Data
Running, John.
Honor dance.
1. Indians of North America—Pictorial works.
I. Title.
E77.5.R85   1985      779'.9700497      85-16444
ISBN 0-87417-100-8

TO MY MOTHER AND FATHER,

GRACE M. RUNNING

AND RICHARD E. RUNNING,

WHO INTRODUCED ME BOTH

TO A WAY OF LIFE

AND TO EVERETT PARKER

WHO FIRST SHOWED ME

A PATH ADJACENT TO

THE RED ROAD.

# ACKNOWLEDGMENTS

There are so many people to acknowledge and thank. Some names that come to mind are Walt Roeder, who told me he would teach me all he knew about photography, and did; Noel Bennett, who showed me how to work with the Navajo and gave me a silver and turquoise bracelet to wear until I was finished; Don and Muriel Hart, who first put my photographs on their wall; Percy Deal, who became a brother; his mother and father, Ella and Leonard, who became my Navajo parents; Annie Homes, who became my younger sister; Dick Greeves; Jeri Greeves; Bill Denny, Sr.; Bill Denny, Jr.; Dick Trudell; Rick Stetter, who has given me his encouragement and enthusiasm for years; Christian Stetter; Sandra Mahan; Rita Bowman; Beverly McLaughlin; and Sue Bassett, who keeps everything together—my children, Raechel Marie and John Paul, who sometimes traveled with me and helped me see innocently and when I traveled without them always hugged me when I returned; their mother, Helen, who told me to use my eyes for the good of all people—Sue Bennett for being a partner, colleague, co-conspirator and mentor.

And then there are the people that I have photographed over the years, so many people who have taken me in, people who fed and sheltered me, people who gave me their image and told me their stories. I can never thank them enough. This book is a way to begin saying thank you.

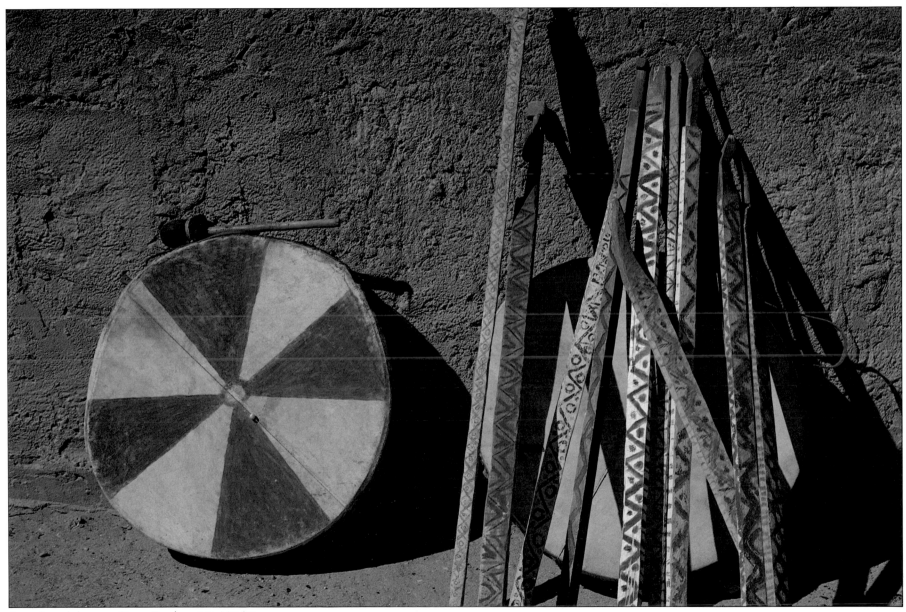

Swords and drum    Sierra Tarahumara, Mexico

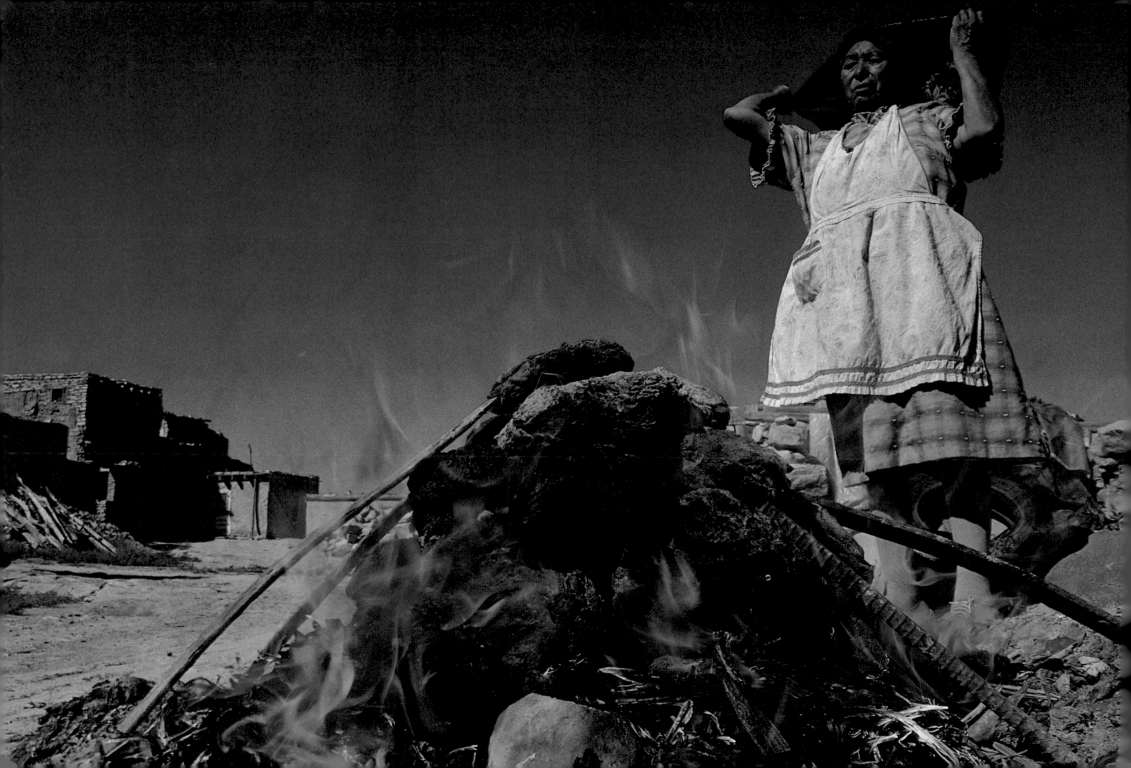

# CONTENTS

Potter
Acoma Pueblo, New Mexico

# FOREWORD

*John Running.* I met him for the first time by chance on a side street in Flagstaff, Arizona. It's not often I run across professional contemporaries when I'm working. For the most part I suppose that's the way it should be. Good photography is, at its best and worst, a solitary pursuit. But this was a chance encounter I welcomed because, in some ways, I had already met John Running much earlier, years past, through his pictures.

I can remember one of the first Running photographs I saw. It was of a cowboy, a black and white image richly printed. When I saw it I felt that I knew something about the man in the picture, although I'd never met him in the flesh. The best kind of photographs can do that; they can make you feel you know something about the subject of the picture beyond the obvious. I think it has something to do with acceptance of the photographer by the subject. I think John Running truly cares about his subjects, and it shows.

Running is perhaps best known for his photographs of Indians, but instead of considering himself a specialist, he considers himself to be simply a photographer of *people*. This is an important distinction. The kind of approach this photographer takes in his work is transferable to any part of the world, to any society. He is never just photographing the trappings of religious beliefs or the costumes of ideology; he is always photographing human beings.

Singer
Browning, Montana

Of course, that's much easier to say than to do, especially when one approaches a society that may display suspicion and perhaps hostility to photographers in general, and to white photographers in particular. There are few places in the United States that can make one feel more of an outsider than an Indian reservation if one is white and carrying cameras. And for good, old, and obvious reasons. But John Running has transcended the barriers of distrust. Probably only he and his subjects know why or how; maybe Running doesn't know himself. But it's not the why or how that's important, anyway, it's the work.

The history of the American West and its inhabitants—both native and those who came later and stayed—has been documented by photographers for well over a century. To compare the work of one photographer to another—when there may be half a century or more separating their efforts—is, at heart, an exercise in futility. But because a lot of Running's work is about Indians, his efforts will be examined and compared to others who have portrayed Native Americans in the past. One name that comes to mind, of course, is that of Edward Sheriff Curtis. The work of Curtis, done over a period of more than twenty years, beginning in about 1904, has been both acclaimed and criticized. From a standpoint of effort and volume, the photographs of North American Indians by Curtis remain a very considerable achievement.

In a number of ways, as a photographer, John Running is not an Edward Curtis. He certainly doesn't have to struggle with the heavy, cumbersome photographic equipment that Curtis had to deal with, nor does he have to contend with the limitations presented by the film and lenses of Curtis's time. But again,

that really isn't what matters. Cameras and film are tools, and although the tools have been improved and sophisticated beyond what Curtis probably imagined in his time, it is still the vision of the photographer that matters. And that is where these two photographers seem to part company.

There is a definite similarity between the portraits of Curtis and those of Running. Both employ a direct approach, utilizing simple, unobtrusive backdrops, concentrating on the strength of faces. Today, however, some of the non-portrait work of Curtis is open to question regarding how he structured and directed some of his images. His work was at times a kind of staged re-creation of a way of life gone by. A romantic, sometimes inaccurate, veil was carefully laid across the face of reality.

With John Running that veil has been lifted. Away from his temporary makeshift studio with its simple canvas or adobe background, Running drifts around the edges of reality and watches, seeing in his own way and proceeding, quietly I suspect, to make some visual order out of the moment. He doesn't romance us. The baseball caps, sunglasses, and football jerseys are included in Running's pictures because they are a part of his subject's reality.

It has been said that Indians once disliked photographs, fearing they were capable of stealing one's soul. John Running has said that isn't true, and today it's probably not a belief held by many Native Americans, although I think a hundred years ago it may well have been. But there is no theft involved in these pictures. Most of these photographs are the result of moments given to the photographer willingly, and you can't steal what is meant as a gift. Running has received these gifts and has given

something back through a genuine concern for his subjects, their lives, and a culture, more often than not, forgotten.

There is a simplicity in these images that is harder to achieve than it sometimes appears. This is not necessarily a new way of seeing, but rather a refinement of a traditional kind of photography. This is a book of honest photographs. And in the words of an old cowboy friend, "That kind ain't runnin' around in bunches."

A fine photographer's voice can be heard through his or her pictures.

Look at the photographs of John Running and listen.

*William Albert Allard*

"TO SEE

TO RECORD

TO COMMENT

this is the work of documentary photography
to explain man to man and each man to himself."

Edward Steichen

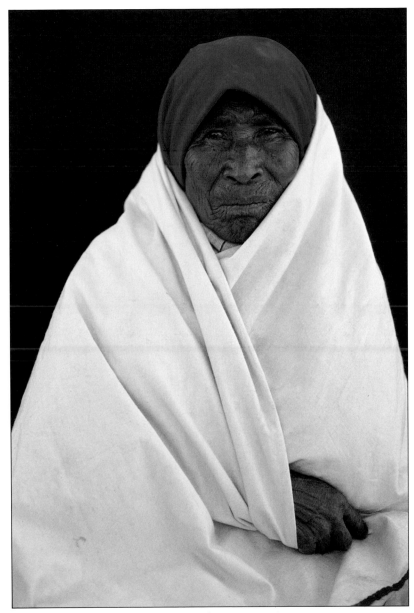

Madre de Andres, 1980    Sierra Tarahumara, Mexico

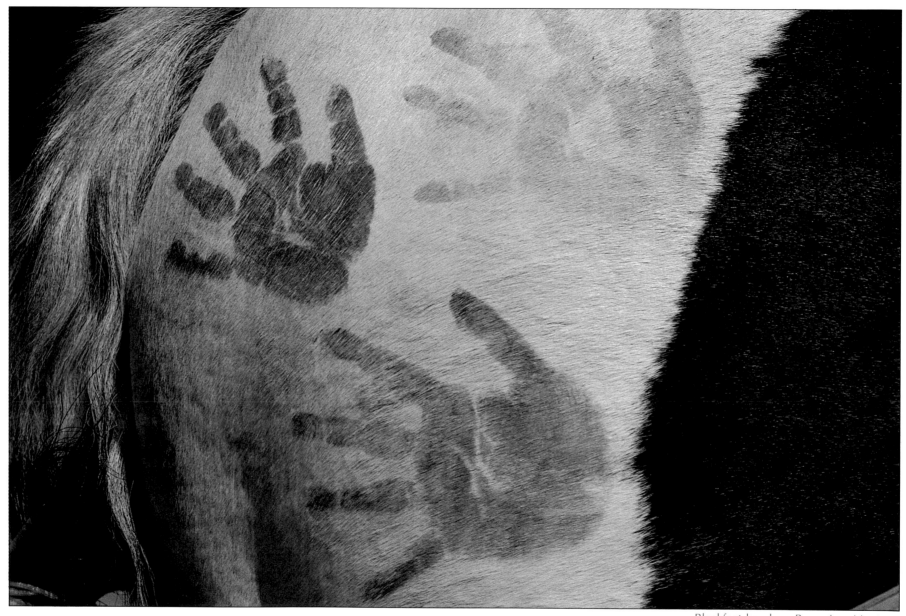

Blackfeet hands    Browning, Montana

I think of the term, honor dance, in two ways—first, the actual Honor Dance as given on the Plains, and then the metaphor as I am using it in this book.

Honor dances are usually given at pow-wows or special public occasions. Their purpose is to honor an individual for any number of reasons—perhaps for a child on the occasion of receiving an Indian name, or for a serviceman on his safe return from duty, or to commemorate a young person's successful completion of college, or becoming a lawyer or doctor. Other times an Honor Dance is given to commemorate those who have passed away, be it recently or many years ago.

The Honor Dance is more a procession than a dance. The individual being honored and the immediate family walk a circle inside the pow-wow arbor. This is usually a circular enclosure where people sit, within which the pow-wow participants dance. A drum plays the individual's honor song. If he doesn't have his own song one may be borrowed from a relative or close friend. The drummers sing. Spectators stand as the Honor Dance begins.

The honored one enters the arbor walking slowly, gently to the beat of the drum and the sound of the song. In the case of someone deceased, a close family member will carry a portrait or photograph; for a veteran someone will also carry the person's own American flag, the stars showing folded in a triangle.

The immediate family follows. As the drum beats and the honor song is sung, the family makes their way around the arena and is eventually joined by other family members and friends; as they join the dance they might slip some money into the hand of an immediate family member to help defray the cost of the feast and give-away that usually follows the dance. The people fall in line behind the family, men remove their hats, woman slip on their shawls, and thus they make their way around the circle, honoring the living and the dead, honoring their Indian way of life.

I would like to compare this book to an Honor Dance—my photographs giving honor to Indian people and to a way of life in which dance has a special place. Among the Pueblo tribes, dance is a prayer. The Tarahumara dance to save the universe from evil. The Plains people dance their prayers and for their honor.

Many of the photographs in the book are of dance or dancers. Dance. Photographs. Honor. A book. They all come together here.

I cannot dance the Indians' dance. But I can offer my photographs and this book. The photographs are my songs, the book is my dance. Together they are my dance and my prayer to give honor to Native Americans in particular and mankind in general.

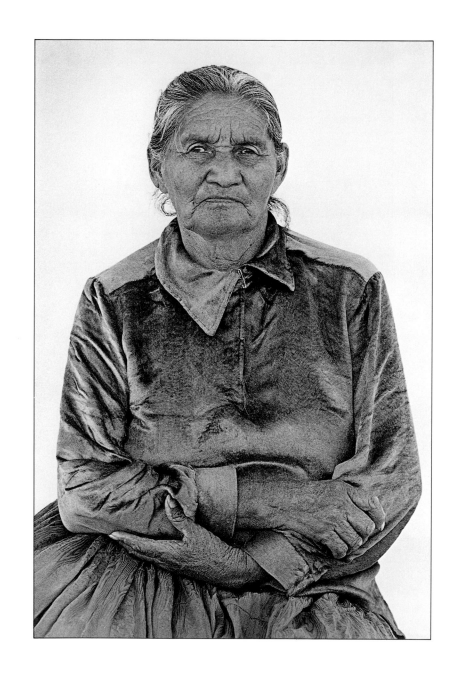

The land dispute is over now. The land dispute between Navajo and Hopi began perhaps in prehistory when the Athabascan-speaking Navajo migrated into the Southwest from their prehistoric homeland in the Northwest Territories of Canada and eastern Alaska. There were tribal conflicts. But the land dispute, as it is known today, had its beginnings in 1882 when President Chester A. Arthur issued an executive order setting aside 2.5 million acres in the heart of the larger Navajo Reservation in northeastern Arizona for the Hopi and "other such Indians as the Secretary of Interior may see fit to settle thereon." The ambiguous wording of Arthur's decree caused conflict between the two tribes from the beginning.

Congress and the courts have attempted since 1882 to define the intent of the decree and to mediate the dispute between the two tribes. But it seems all they did was make things worse. In 1962 the courts established the Joint Use Area and ordered a freeze on all construction, repairs, and improvements within the Joint Use Area unless agreed upon by both tribes. In 1974 Congress passed the Navajo-Hopi Land Settlement Act to "provide a final settlement of conflicting rights and interests of the Hopi and Navajo tribes to and in lands lying within the Joint Use Area," giving the federal court the ultimate authority to partition the disputed area. In 1977 the court issued its partitioning order.

Ashakie Bitsie
Maternal Clan:   Edgewater
Paternal Clan:   Apache

A zigzag line was drawn through the map of the Joint Use Area. It was ordered that 9,000 Navajos living on land awarded to the Hopi, and 100 Hopis living on land awarded to the Navajo, would have to be relocated. Relocation is to be completed by 1986.

The land dispute is over now according to Congress and the courts: the land has been divided, the barbed-wire fence is almost finished. But the human impact of relocation has not been considered. Many of the relocatees are among the most traditional of the Navajo people. They are pastoral and so are bonded to the land in ways that are difficult for most non-Indians to understand. The land is the most important thing in Navajo life. The land defines and identifies these traditional Navajo people. Many speak no English and have no desire to live in the white man's world. Furthermore, partition separates the Navajo from many of the sacred places necessary for their worship and healing. To order these Navajo people to move, to sell their sheep, to leave their land, is to destroy their cultural identity, to destroy them.

I have Navajo friends affected by relocation. They asked me to help them fight relocation, to take pictures, to show the world about relocation. The people living in the area around Big Mountain want to fight relocation and fencing. They live in an area that is especially sacred and cherished. Big Mountain is the place Navajo people go to pray and to make offerings for their livestock and to gather both sacred and medicinal plants. Big Mountain is on the Hopi side of the barbed-wire fence. The Navajo living in the area around Big Mountain had a meeting, considered many ideas, and then finally agreed, "Let's make a book." They discussed the idea at a meeting held in the shade of an open-sided ramada. "Let's make a book of pictures and then put the pictures together with our words." A Navajo friend I call "little sister" pointed at me the Navajo way, with pursed lips, and said something in her own language to the group. Later she told me she had said, "Let him make the pictures. He takes pictures of the truth." And then she repeated it three times, a Navajo way for adding emphasis. To which one of the older women replied, "Good. Let me be first. You take my picture!"

I made these pictures for the Big Mountain people, working as their advocate. I want you, the viewer, to look past the numbers, into their eyes, to consider their words, to look at a face. There are about 20 people photographed here. Just think for a minute. For every person you see here, there are 500 more Navajo faced with the uncertainty of relocation. Look at these people, read their words, consider their rights, think about your rights.

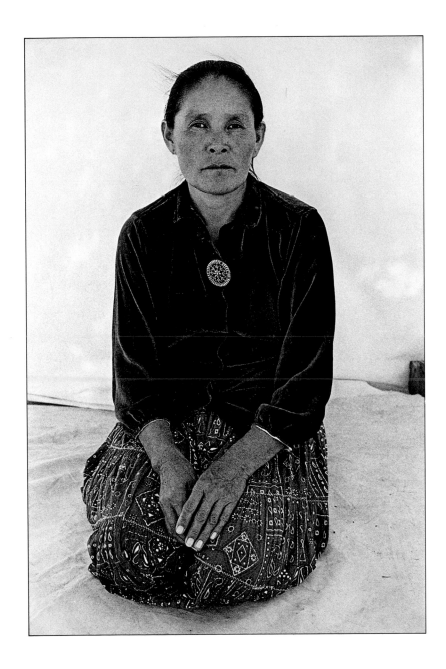

I was born and raised at Big Mountain, northwestern Arizona. I never had an Anglo education. My father died one month before my birth. My mother taught me the values of raising livestocks.

This is a responsibility that is passed on to us from our fore-fathers. We must maintain, protect, and carry out this livelihood, even if it has to be a painful struggle at times. It has been a happy way of life until they told us we had to sell our live-stocks, and that our land belonged to the Hopi and that we would have to move.

We are all told to sell the livestocks, but what will we eat? We are told the land belongs to the Hopi, but my mother was born here, my grandmother was born here, and my great grand-mother was born here. We are told to move, but we will not go.

Jane Biakeddy
Maternal Clan:    Edgewater
Paternal Clan:    Salt

I was raised as a livestock person. My only life has been as a sheep herder and a cattle person. I do not know any other modern skill. I do not own a truck. My only transportation is my horse. If they make me move to town, I will not be able to keep my horse.

Daniel Ashakie
Maternal Clan:    Edgewater
Paternal Clan:    Apache

Mazzie Begay
Maternal Clan:    Ta'chinie
Paternal Clan:    Edgewater

Joe Lee Begay
Maternal Clan:    Many Goats
Paternal Clan:    Bitterwater

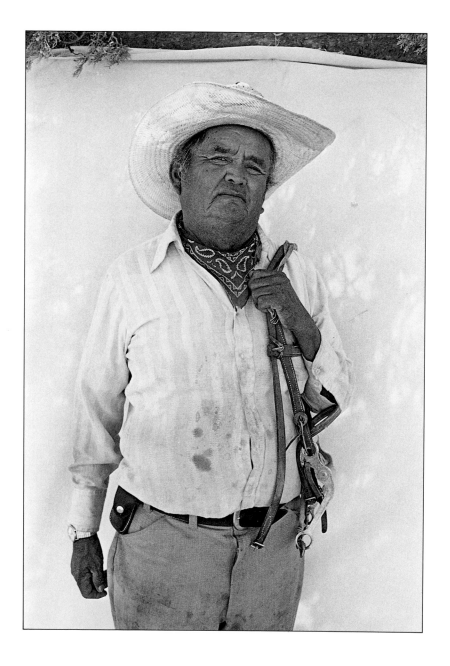

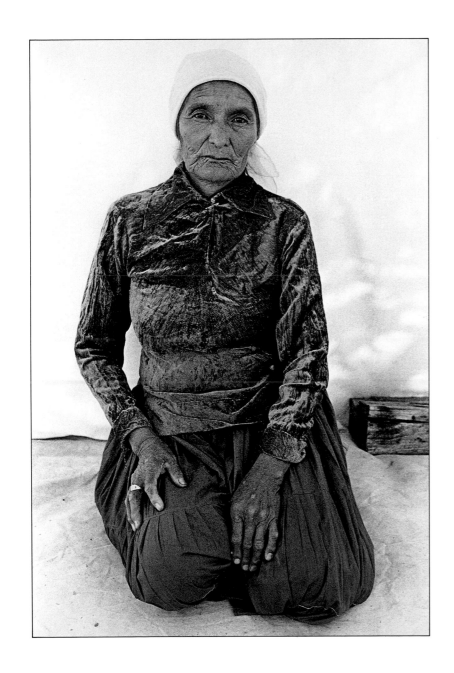

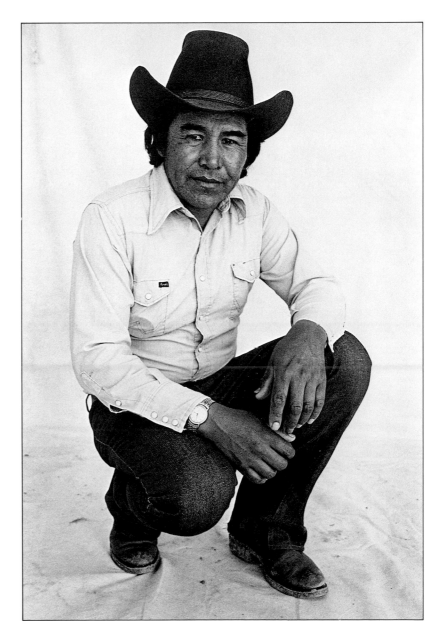

I was born into a family that only raises livestock. I have raised my family with livestock. The sheep give us food and wool. The sheep give us joy seeing them in the corral. The sheep sound nice to my ears. I have never had a modern job. I only know livestocks.

The federal government tell us this is not Dine' land. We know that it belonged to the old ones, Anasazi, who were destroyed by wind and fire thousands of years ago.

We've never gotten any real or satisfactory help from the federal government. Why is the Anglo taking our livestock?

The white man runs around with his law. It is his law, and only he can understand it. We don't understand and will not obey it. We are human and we can break and disobey this law.

We will keep this land of our own. If the federal government won't respect our natural law, we won't respect their law.

Joe Benally
Maternal Clan:   Edgewater
Paternal Clan:    Apache

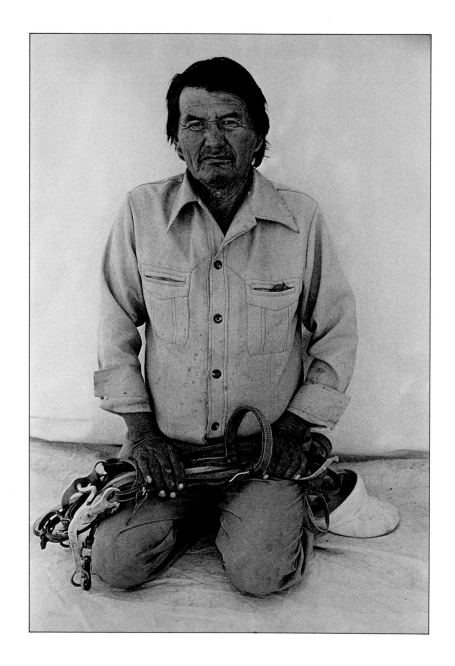

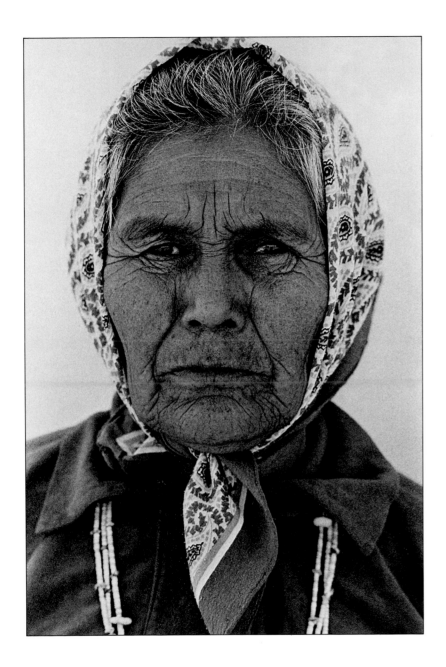

I oppose the fencing. I want the fencing stopped.

What will become of our life? I fear for my life and all my family and relations. These ideas go through my mind night and day. It has affected my health.

Our elected officials don't care about our situation. We plead for help but get no answer. I have even gone to Washington, D.C. The government has damaged the lives of our Indian people. We will keep our land with our livestock and our children with it. I have not given up yet.

There is a ruin of the Ancient Ones near my home. The fence builders are very concerned and careful about digging too near the ruin site. But no supervisor has any concern for the safety and beliefs of those of us who are still alive and make our livelihood here. They care about ruins but they don't care about Dine'. They will bulldoze down our home if we get in their way. The workers are drinking. When you say something to them, they talk to you like you are a dog and make fun of you.

The land is for my children and my grandchildren. This is not the first time we say this. This land belongs to us.

Alice Benally
Maternal Clan:  Nakai Dine'
Paternal Clan:  Clauscheei

When the time comes, if we don't have any other choice we are going to use our fists. No matter how small I am, I'll fight all the way to the end. After we throw our punches, if we get clubbed to death, then they can drag us out. They told us to get rid of our livestock. Now they are trying to get rid of us. They are trying to kill us.

Ruth Benally
Maternal Clan:  Nakai Dine'
Paternal Clan:  Clauscheei

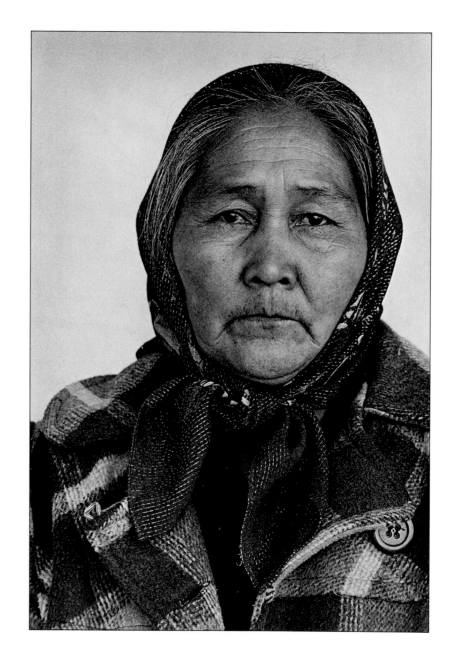

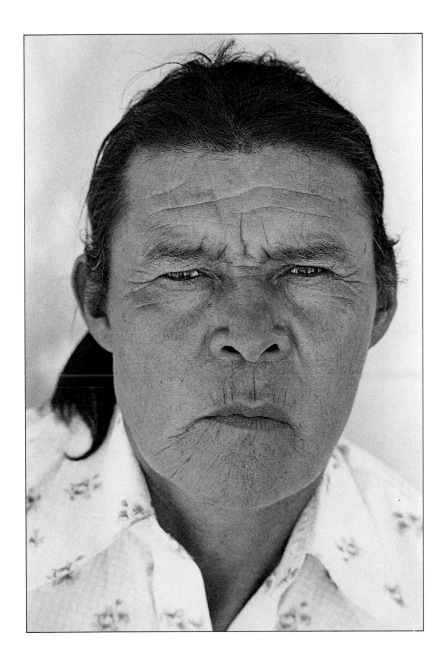

I do not like relocation, stock reduction, or fencing. Big Mountain is for the people who live here. It holds our prayers. I will not relocate even if I am forced to.

The mountain is ours. It is the place we go to pray for our livestocks, and our medicine men go there to get herbs, and it is the place our women gather the medicine they use when they bear children. We need the mountain to live.

Also we need the sheep to live. If the sheep are gone we will have no mutton to eat. We will not have sheep to take to the trading post to exchange for other food and merchandises. There will be no wool to sell or for the women to weave.

The sheep and the mountain are necessary for our life.

Kee Shey
Maternal Clan:   Edgewater
Paternal Clan:    Salt

We know that only two white men sat at a piece of board to decide what was good for us. We can think for ourselves. So why is someone else making decisions for us? We are always hearing the story of how we overgraze our land and destroy our own land. They scared us into having to defend our land, so we fought overseas in your wars. When it was over the ones still alive had to hitch-hike home.

The white man runs around with his law; it is his law, only he understands it. We don't understand it and will not obey it. We're human beings, we can break and disobey this law.

Dan R. Yazzi
Maternal Clan:   Coyote
Paternal Clan:   Tall Tower

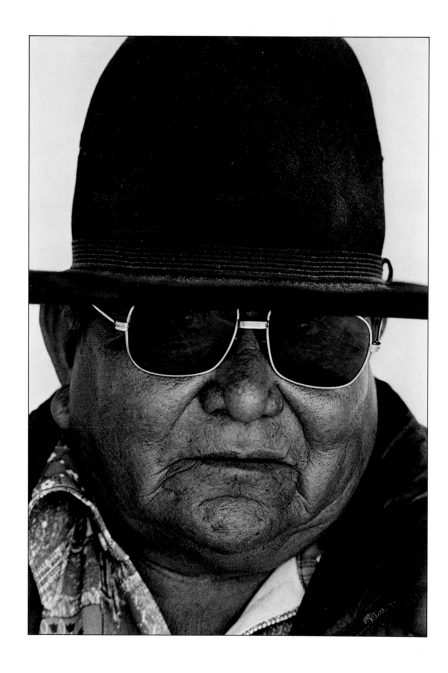

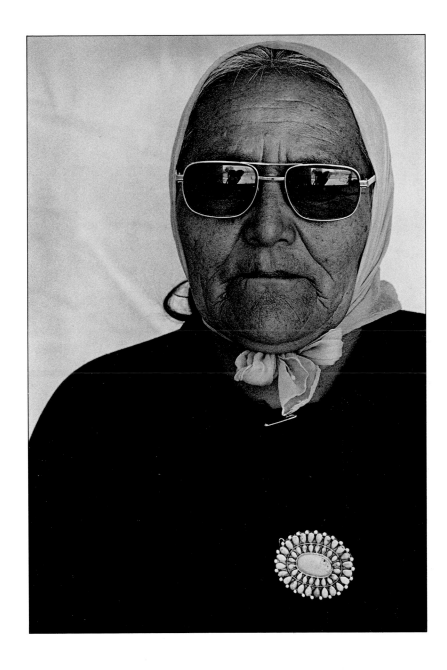

We are being distributed by the action of the United States through their courts. Today I know why the government is tearing my people from their place of birth. There is a large sub-surface coal deposit and other energy resources where the Big Mountain people live. They want to get rid of us. We are the caretakers of the area.

The government has strong intentions to dominate and destroy the Navajo way of life. First they reduced our livestocks, then fenced the area with barbed wires, and now we are being taken to courts hundreds of miles away for building new housing, but our old homes are ready to collapse on us.

I speak for my children and their children, our Native Indian culture, our sacred teachings and our tradition that allows all walks of life to live in harmony and goodwill side by side.

So now I often lay awake at night wondering where I will get a cat that will kill the mouse [the government] that is eating away at my belongings.

In our traditional tongue there is no word for relocation. To move away means to disappear and never be seen again.

Pauline Yazzi Begay
Maternal Clan:   Many Goats
Paternal Clan:   Tall Tower

Just this morning I was working my small patch of crops. They needed care because they took me to prison. The federal government took me to prison because I would not relocate. My crops need my care, but I will go to prison again if they try to take me from my land.

They told us the land belongs to the Hopi. They bump us in the trash. How do you feel? Leaving me in the trash for the crows and coyotes to pick my bones.

Katherine Smith
Maternal Clan:   Edgewater
Paternal Clan:   Apache

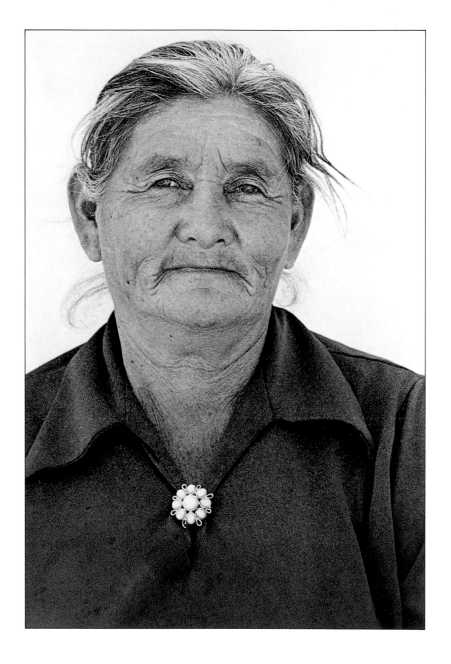

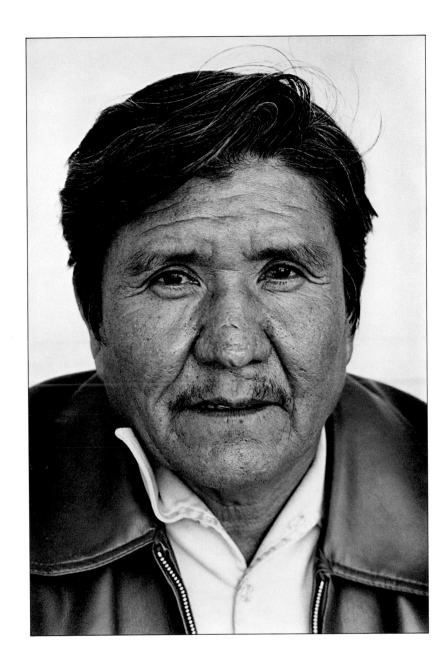

Timothy Begay
Maternal Clan:   Ta'chinnie
Paternal Clan:   Nakai Dine'

Pauline Yazzi Begay
Maternal Clan:   Many Goats
Paternal Clan:   Tall Tower

Mae Jimmy
Maternal Clan:   Tangle Corn People
Paternal Clan:   Tall Tower

Dolly Manson
Maternal Clan:   Chishie
Paternal Clan:   Split Rock

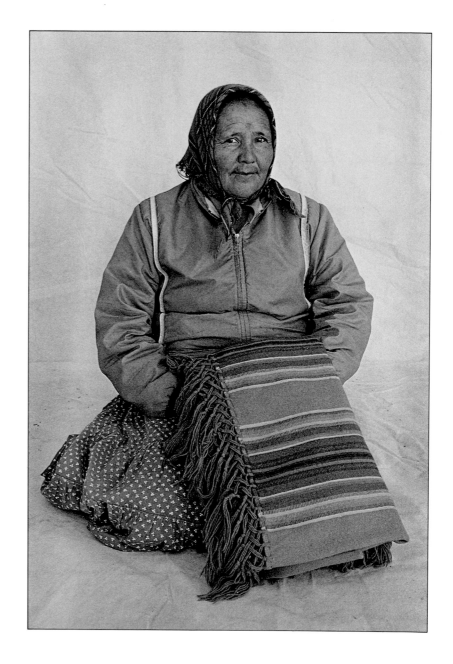

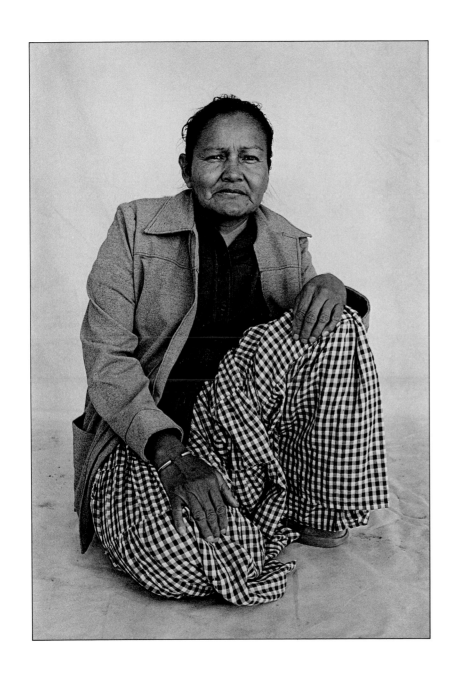

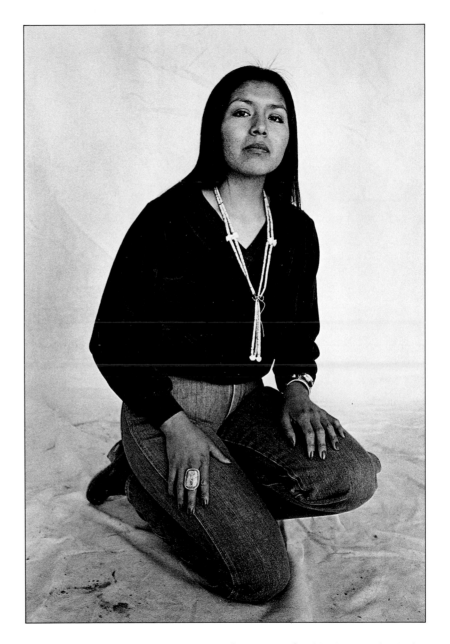

Jean Benally
Maternal Clan:   Chishie
Paternal Clan:   Split Rock

Atson Begay and granddaughter
Maternal Clan:   Ta'chinie
Paternal Clan:   Edgewater

Dora Manson and granddaughter
Maternal Clan:   Clauscheei
Paternal Clan:   Chishie

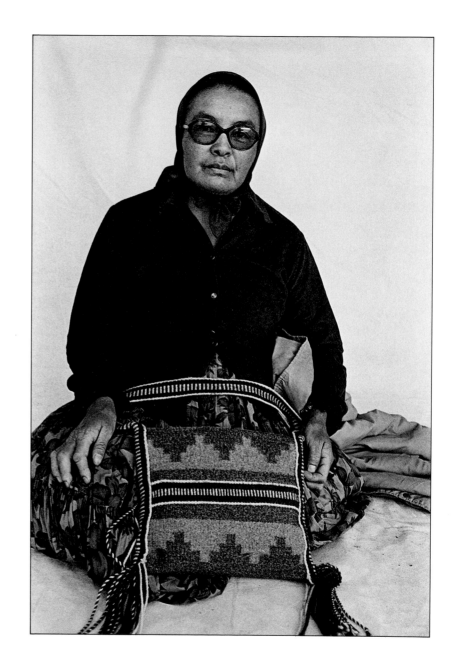

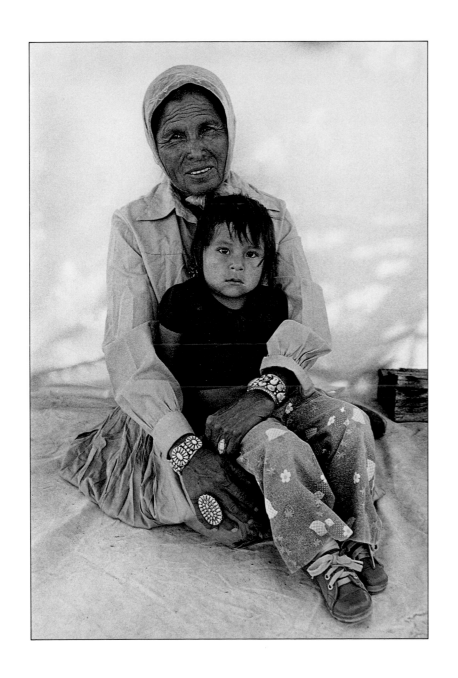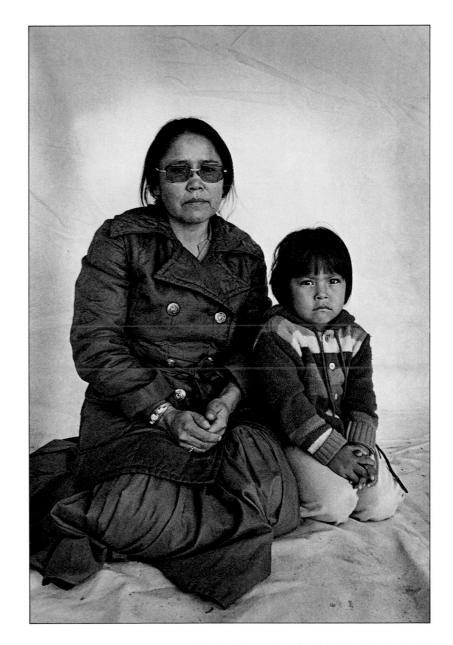

Ruby Biakeddy and son
Maternal Clan:   Ta'chinie
Paternal Clan:   Edgewater

Biakeddy
Maternal Clan:   Bitterwater
Paternal Clan:   Many Goats

Barlet Biakeddy
Maternal Clan:   Nakai Dine'
Paternal Clan:   Chishie

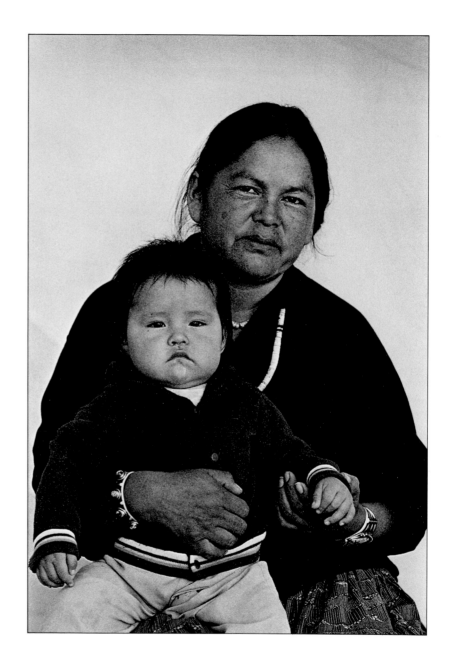

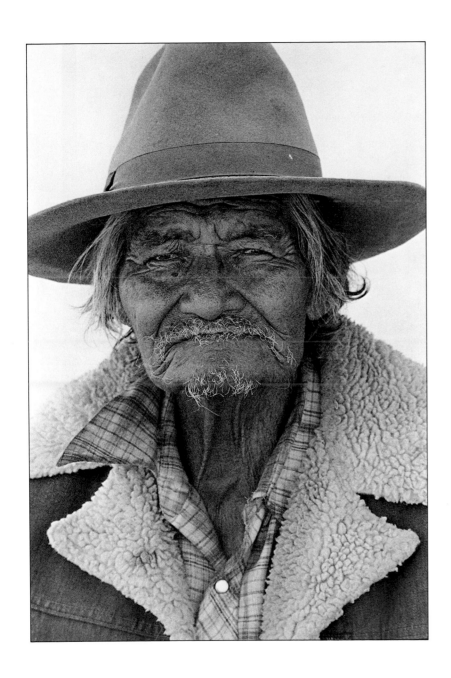

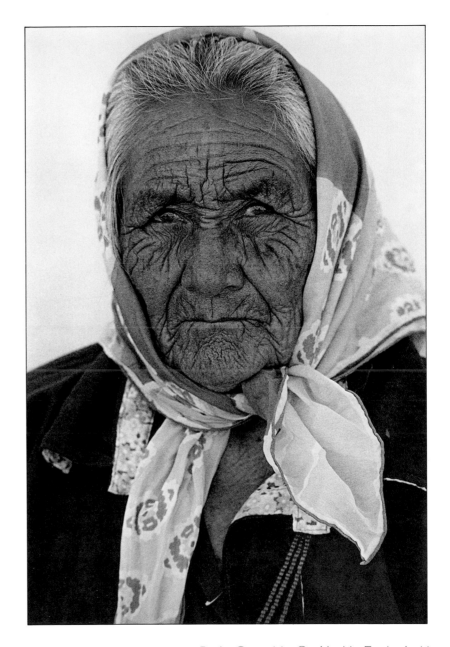

Sleepless nights, food not good. We were here many years ago. The spring is ours. Big Mountain is where my prayer is at. This is where I was raised as a child. Why do you talk about us, our land, our springs? We will stay here forever. It is not good for us to relocate.

Biakeddy

Biakeddy and Barlet Biakeddy
Big Mountain area, Arizona

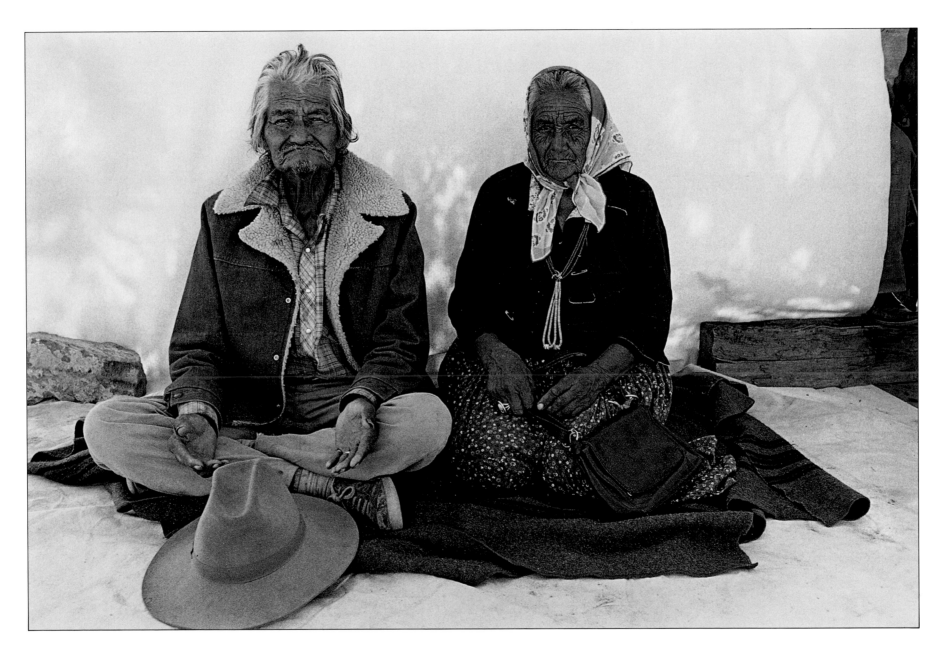

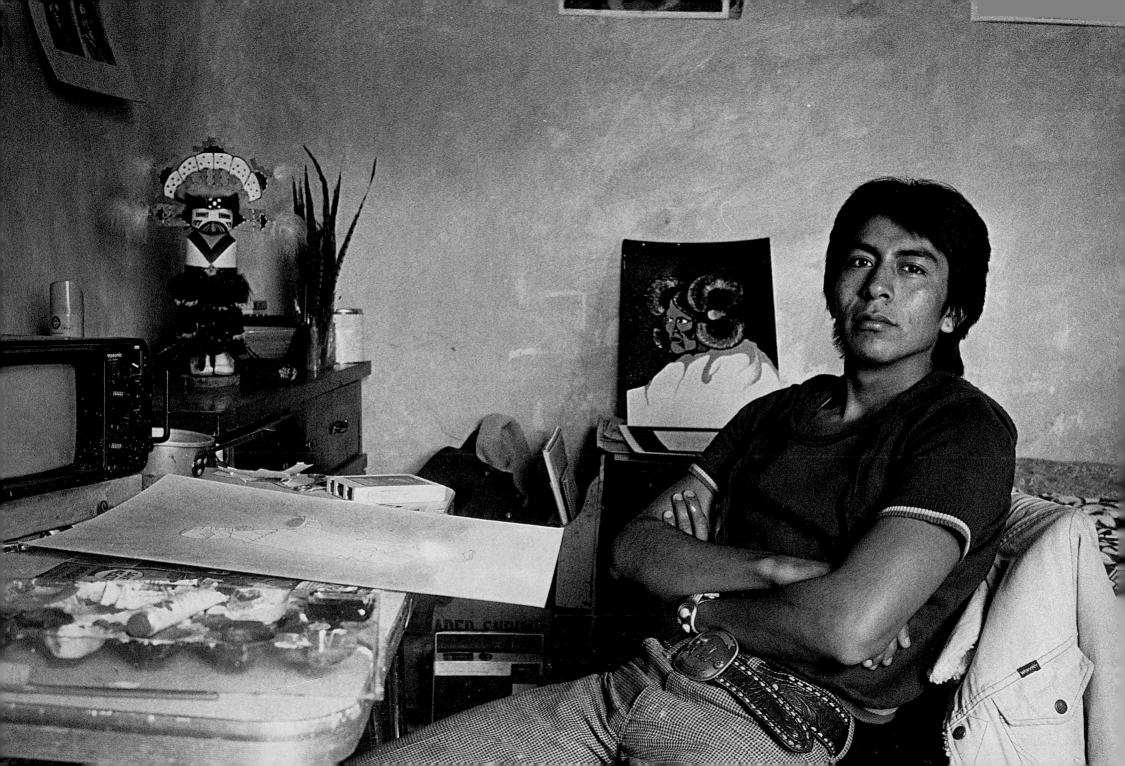

The Hopi live in the oldest continuously occupied villages in North America. They are descendants of the first people to occupy the Colorado Plateau. Their villages are located on high desert mesas in northern Arizona. They live there, plant corn, and dance their prayers. Their prayers help keep our world in order.

I have not spent much time working on the Hopi Reservation because the Hopis don't really like strangers walking around their villages with cameras. Big, hand-painted signs posted outside of the villages declare, "NO PICTURE TAKING ALLOWED." On the other hand the Hopi are some of the most hospitable people I have encountered. It is part of their culture to be friendly. They will often invite an outsider into their home for food or rest from the summer's sun. When I visit Hopi homes I notice photographs are often a predominant wall decoration. Old photos, school photos, photos of servicemen and Polaroid snaps are often collaged together in one great family album on the wall. It is a false notion that Hopis don't want their pictures taken because they fear it will steal their spirit. Their reason is more down-to-earth. They do not want their dances photographed because the dances are sacred. And they don't want photographs taken that make them feel like curiosities.

Hopi artist
Second Mesa, Arizona

A Hopi friend talked to me about this one time. We first met when I walked out into his field to ask if I could take pictures of him harvesting his corn. He answered, "No." I had an assignment to make pictures of the Hopi corn harvest so I persisted and asked again, "I would be able to pay you something if you let me take some pictures of you with your corn." He replied, "I don't need any money, but I need help. You help me tomorrow and then you can take pictures the next day." When I agreed to his offer, he told me that I could spend the night at his home. That evening, after a meal of mutton stew, pinto beans, a kind of steamed cornmeal mush, and boiled coffee, we talked. He asked me about my home. Then he asked me what I would do if my home were visited by thousands of curious tourists and anthropologists each year. He asked, "Would you like to have strangers tramping through your yard, asking why you plant flowers or vegetables and taking pictures of your quaint patio after peering into your open front door? Would you like to live here? I have heard white people call my village a living museum. It is not a museum, it is my home." I thought about the way I value my privacy. I told him that I would find it very difficult to be as hospitable as he was, as the Hopi people were. He replied, "Well, the Hopi villages are not your museum. They are old. We have lived here for centuries and we still live here. We still plant our corn and worship our own way. Think about this when you visit us."

The next day after an early breakfast of scrambled eggs, beans, and chiles we went to the field and harvested corn all day by pulling the dried corn off the stalks, carrying it to the pickup and driving it up to the house. The day after that I made my pictures. I made better pictures because I understood a little more.

The following photographs were made at the request of friends. I gave them copies of the prints. It always delights me to return to a Hopi home for a visit and see one of my photos tacked on the wall with the other snaps.

Hopi woman
Second Mesa, Arizona

Hopi girl
Second Mesa, Arizona

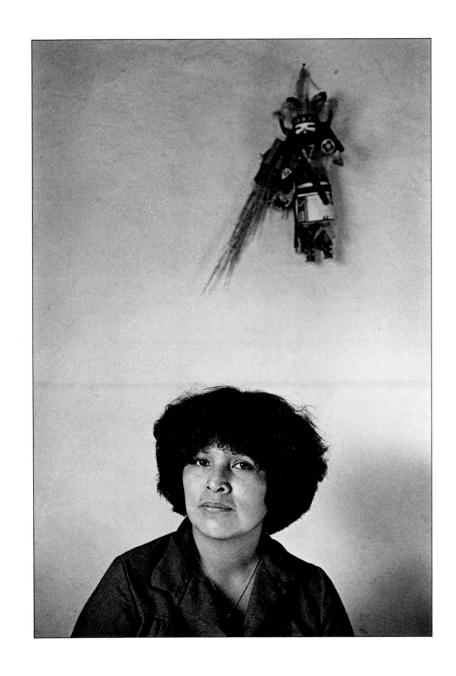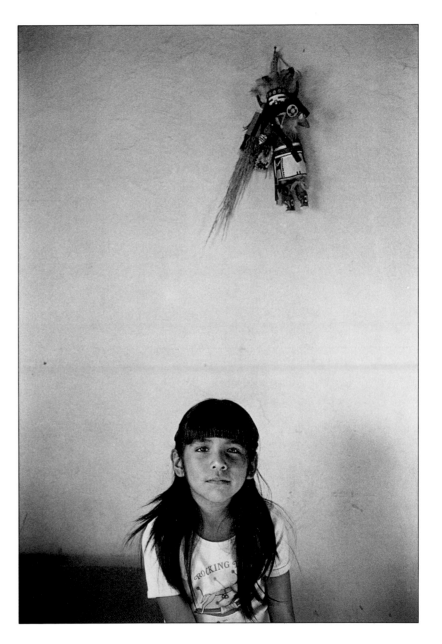

Hopi man
Second Mesa, Arizona

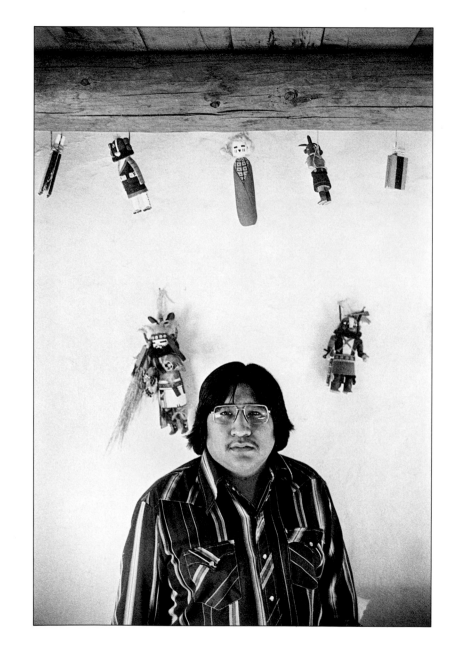

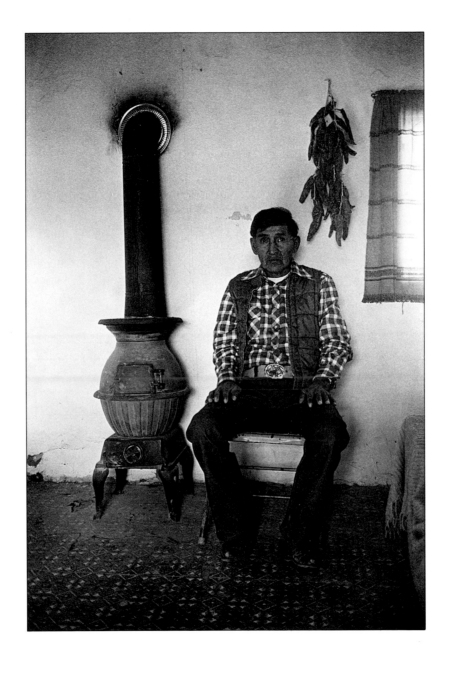

Hopi man
Second Mesa, Arizona

Hopi Butterfly Dancer
Second Mesa, Arizona

Hopi Butterfly Dancer
Second Mesa, Arizona

Hopi Butterfly Dancer
Second Mesa, Arizona

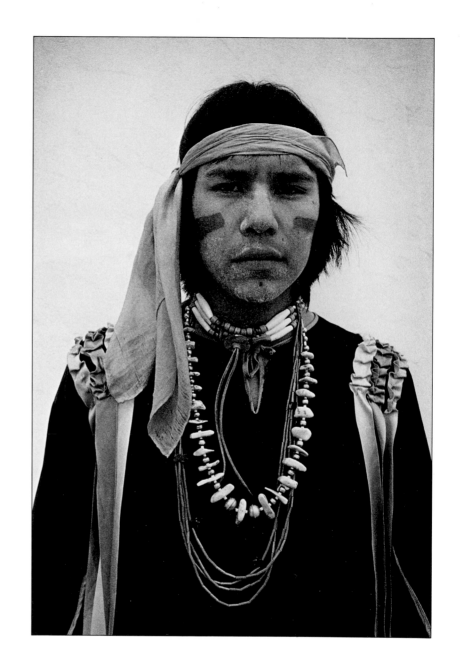

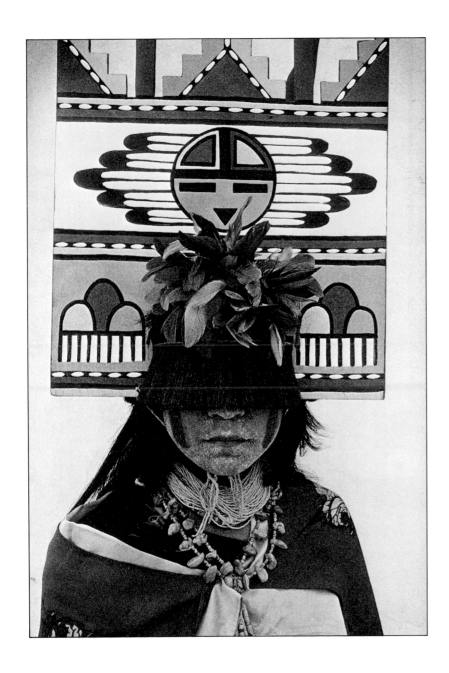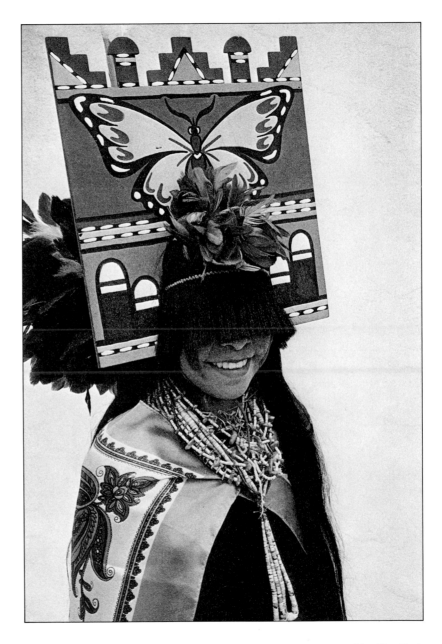

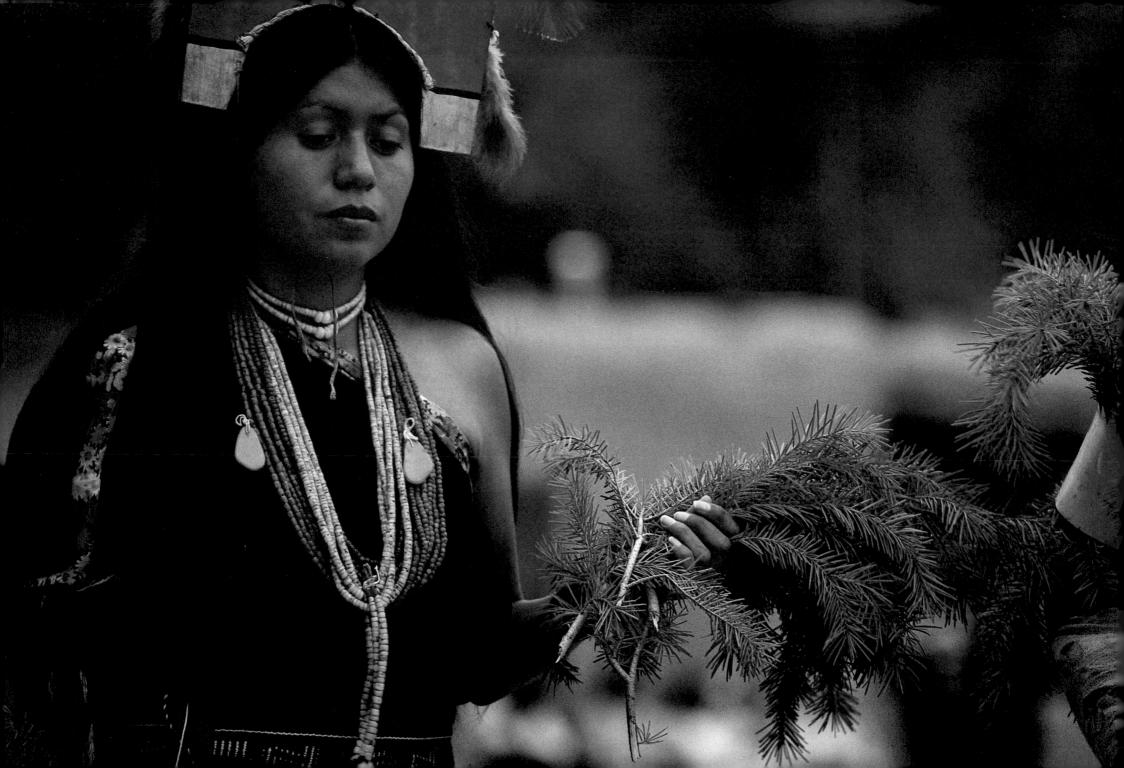

The beat of the drum and the rhythm of the chant—a prayer for rain—reverberate through the plaza at San Ildefonso Pueblo in northern New Mexico. The continuity of these centuries-old traditions survives even as our technological way of life becomes more complex and fragmented.

Listen to the old man sing with his grandson sitting beside him, passing on his songs and traditions from one generation to another. Look at the costumes: the women's headdresses are called *tabletas*, thin flat boards cut in a terraced cloud pattern, pierced with the symbols for sun, moon, and stars. The men wear bandoleers of olive shells diagonally across their bare chests. They have skunk fur wrapped around their ankles to keep evil spirits from rising up their legs through moccasin-covered feet. Smell pitch dripping from pinyon burning in the beehive-shaped ovens, mingling with the scents of yeasty bread and boiling stew. All these sensory messages combined make you feel something inexplicably holy all around.

Different ceremonies are held at specific times throughout the year, and each requires a feast. The ceremonial cycle repeats itself year after year. Spring is the time for rituals of planting, summer for rituals of rain, fall for prayers of thanksgiving and for the coming year, and during winter, animal dances are offered for hunting success and animal intercession with the higher powers.

Corn dancer
San Ildefonso Pueblo, New Mexico

Singers
Animal Dance
San Ildefonso Pueblo, New Mexico

Side dancer
Animal Dance
San Ildefonso Pueblo, New Mexico

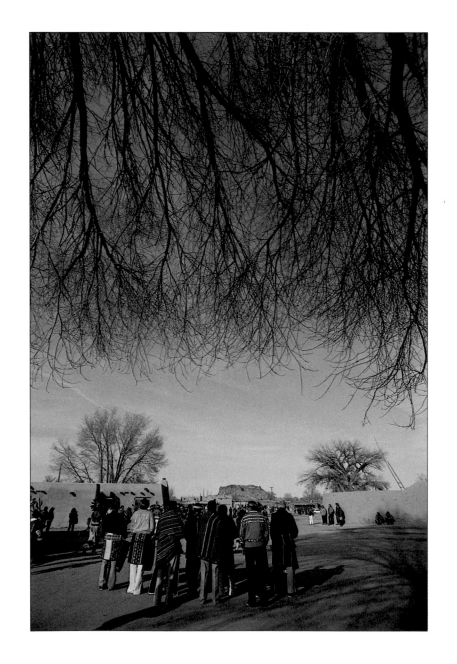

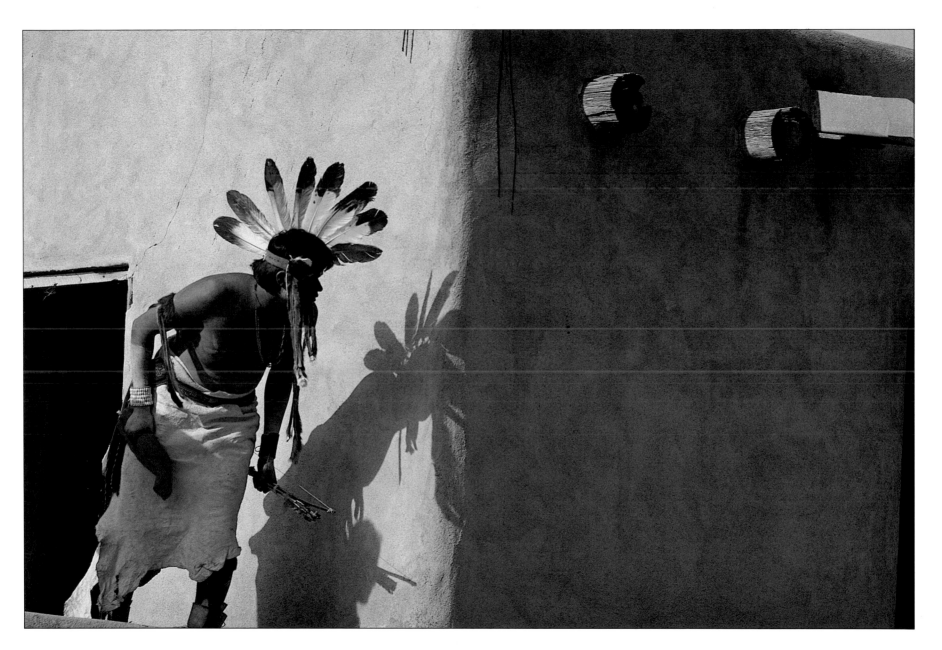

Side dancer
Animal Dance
San Ildefonso Pueblo, New Mexico

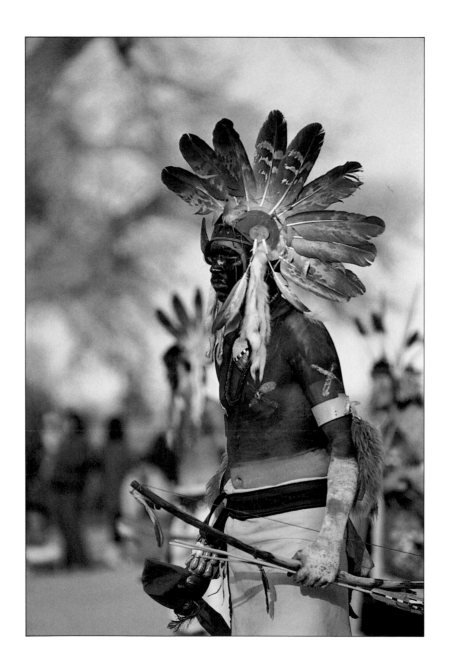

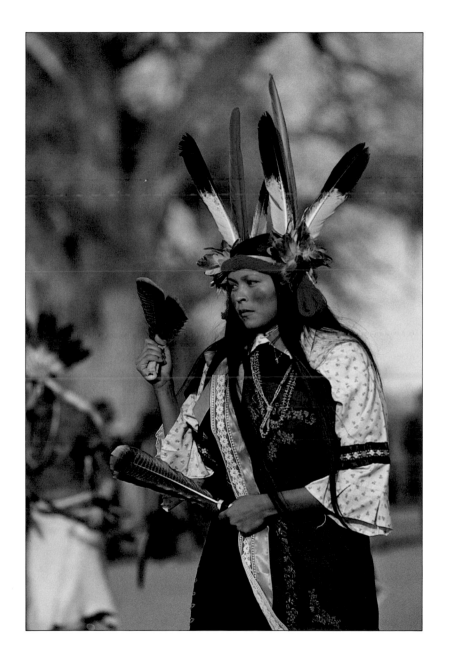

Dancer
Animal Dance
San Ildefonso Pueblo, New Mexico

Singers
Commanche Dance
San Ildefonso Pueblo, New Mexico

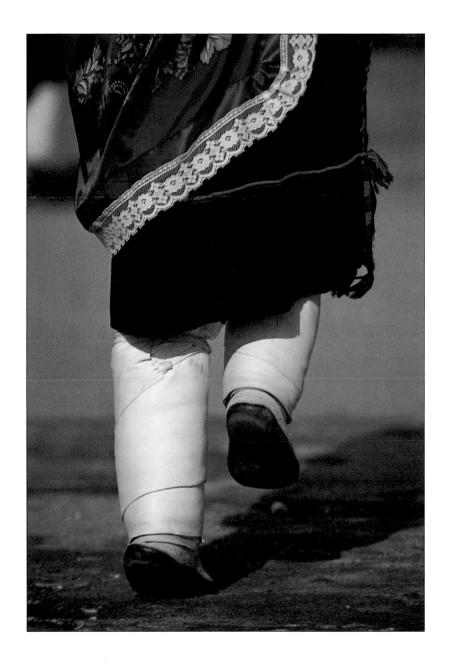

Dancer's feet
Animal Dance
San Ildefonso Pueblo, New Mexico

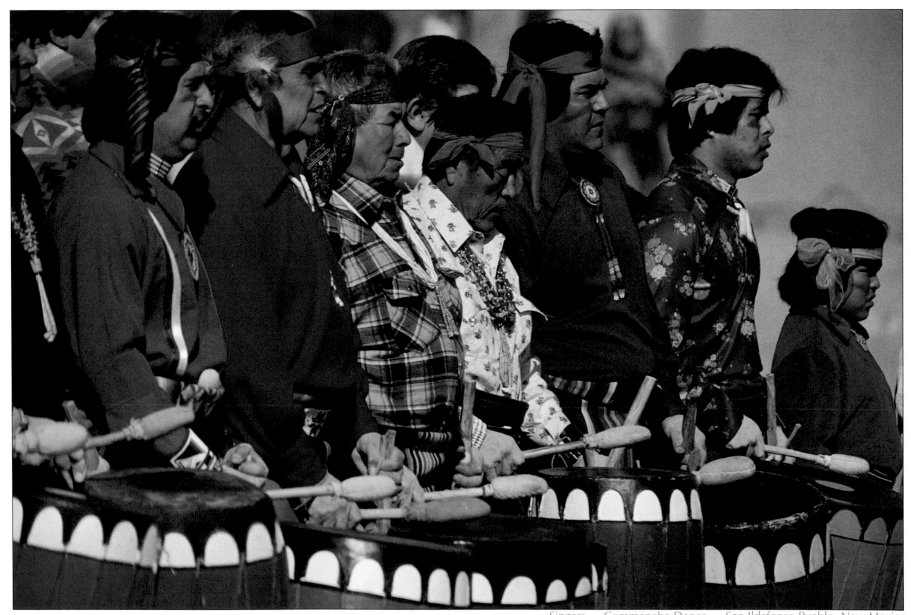

Singers    Commanche Dance    San Ildefonso Pueblo, New Mexico

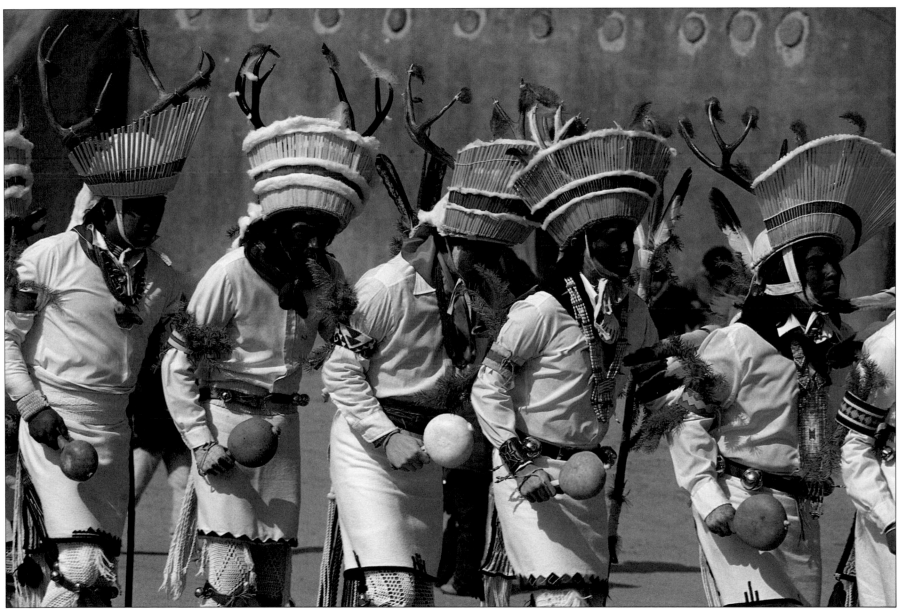

Deer dancers    San Juan Pueblo, New Mexico

Deer dancers
San Juan Pueblo, New Mexico

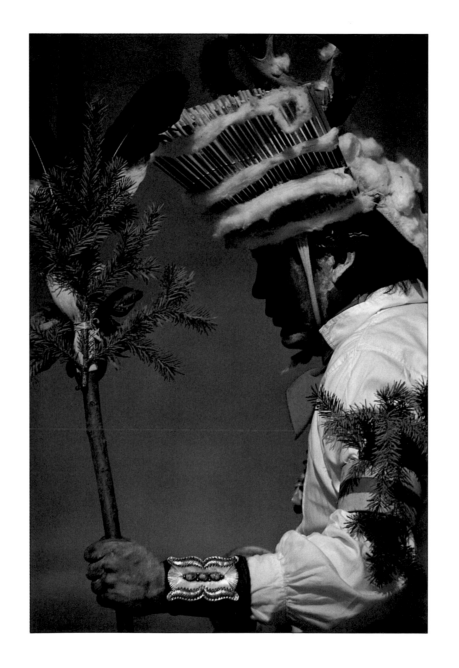

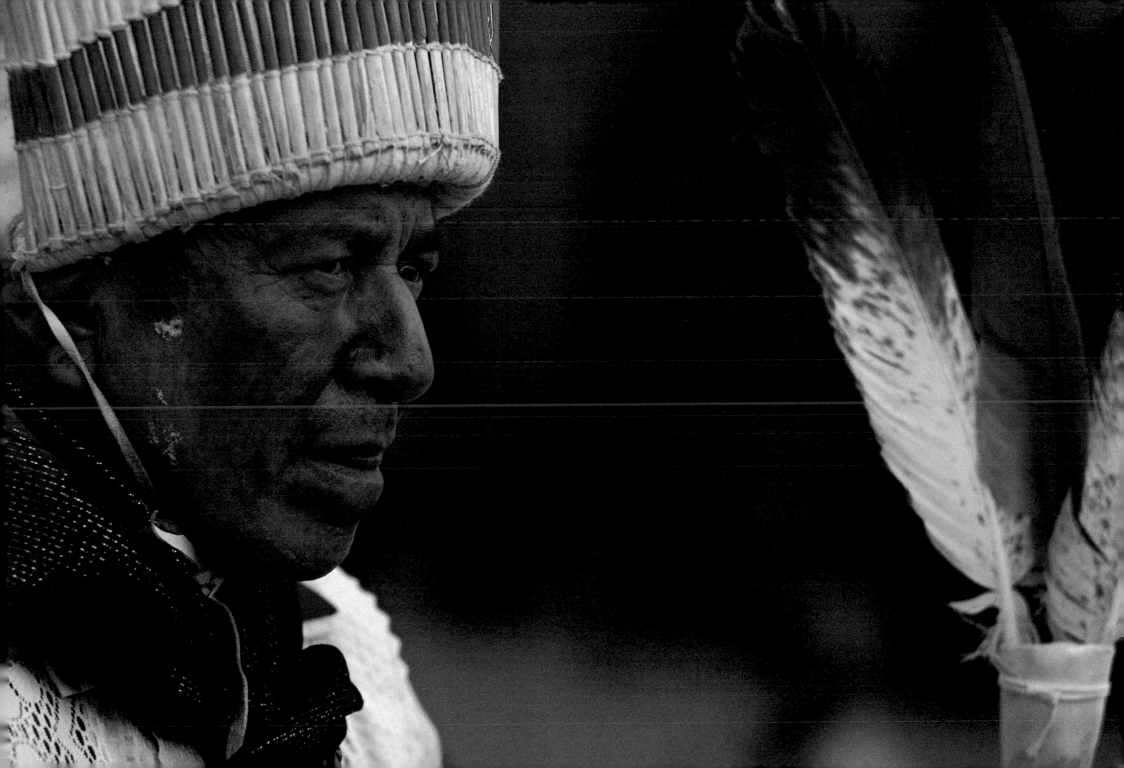

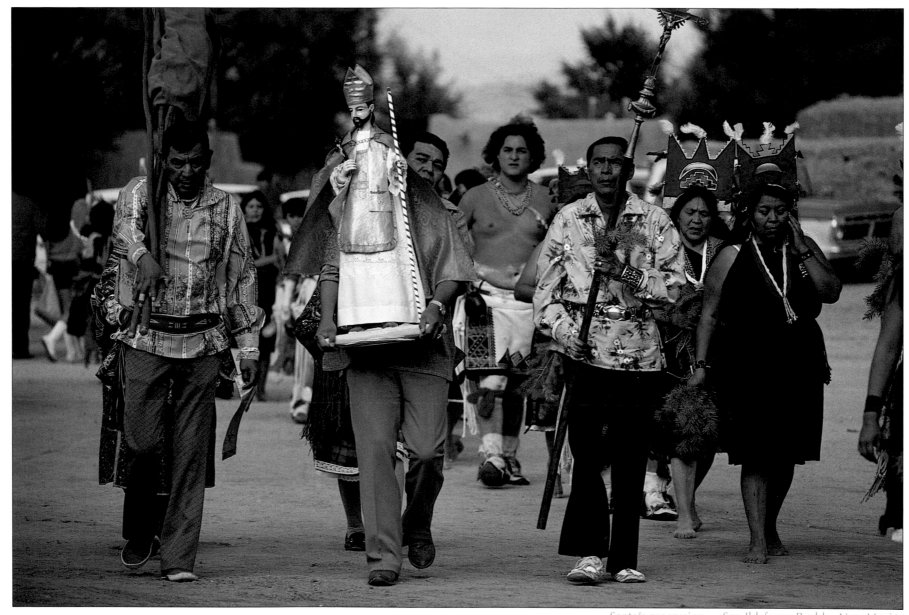

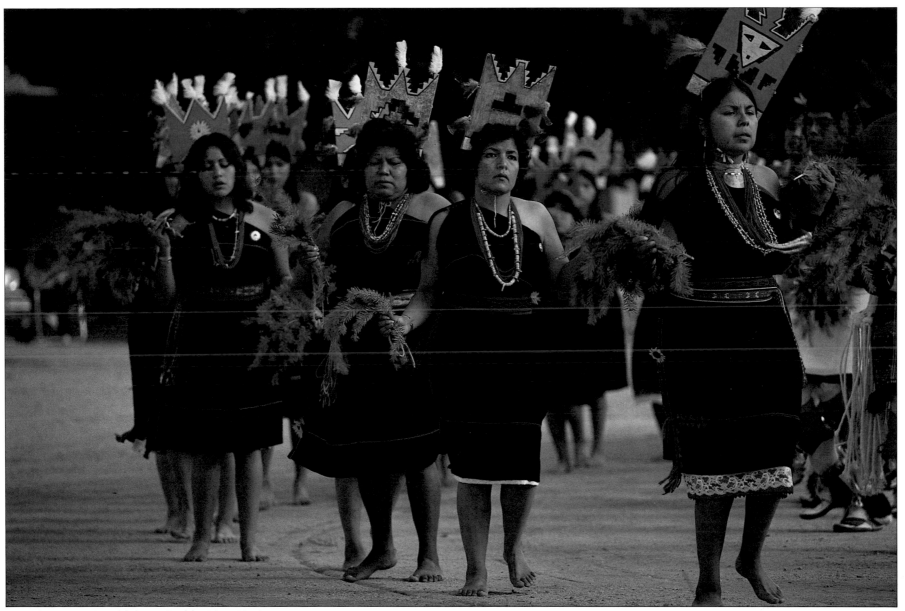

Corn dancers    San Ildefonso Pueblo, New Mexico

Apache hunter
Deer Dance
San Juan Pueblo, New Mexico

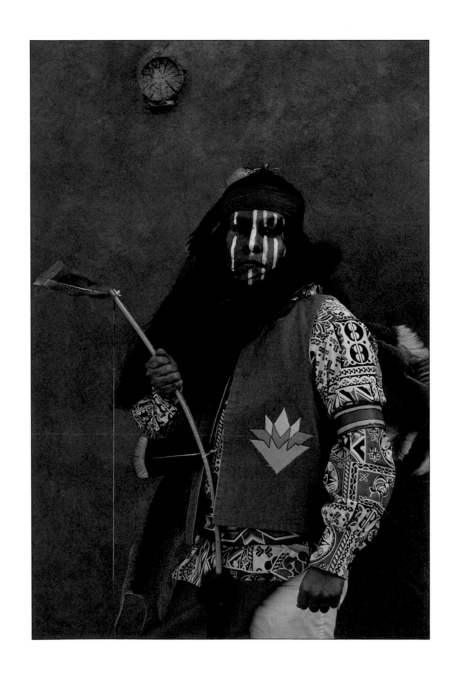

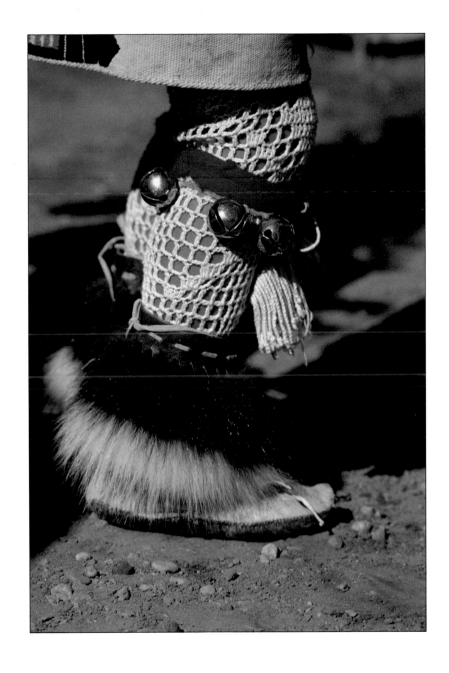

Dancer's feet
Corn Dance
San Ildefonso Pueblo, New Mexico

Corn dancer
San Ildefonso Pueblo, New Mexico

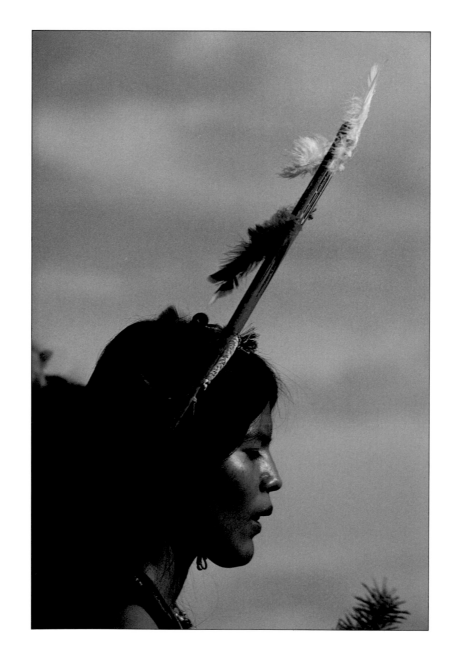

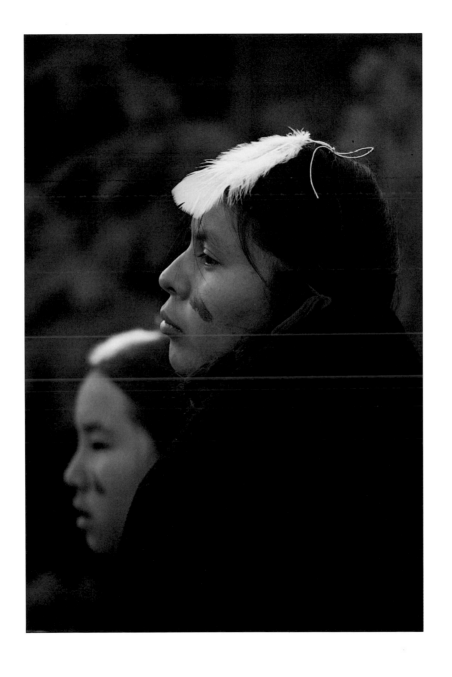

Basket dancer
Santa Clara Pueblo, New Mexico

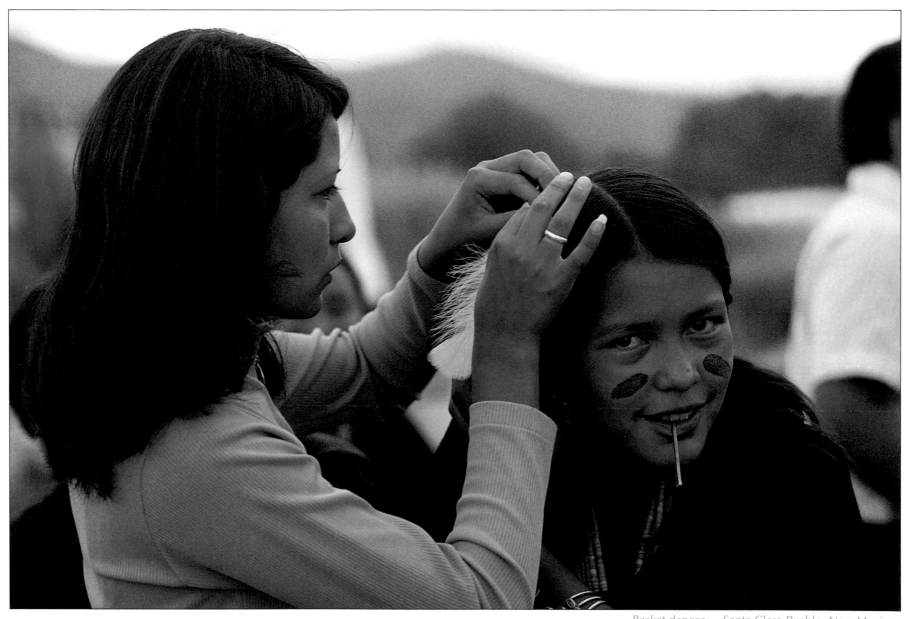

Basket dancer    Santa Clara Pueblo, New Mexico

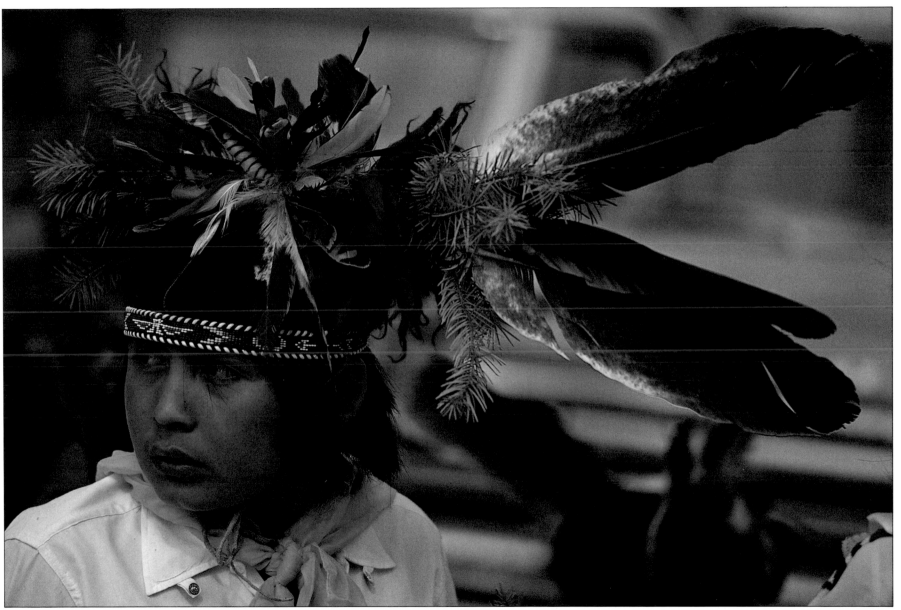

Basket dancer    Santa Clara Pueblo, New Mexico

Buffalo dancer
Santa Clara Pueblo, New Mexico

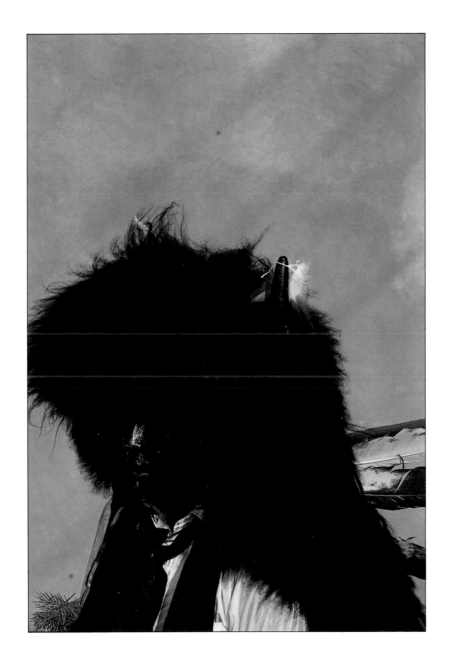

Buffalo dancer
Santa Clara Pueblo, New Mexico

Kiva
Santa Clara Pueblo, New Mexico

Harvest dancers
Santa Clara Pueblo, New Mexico

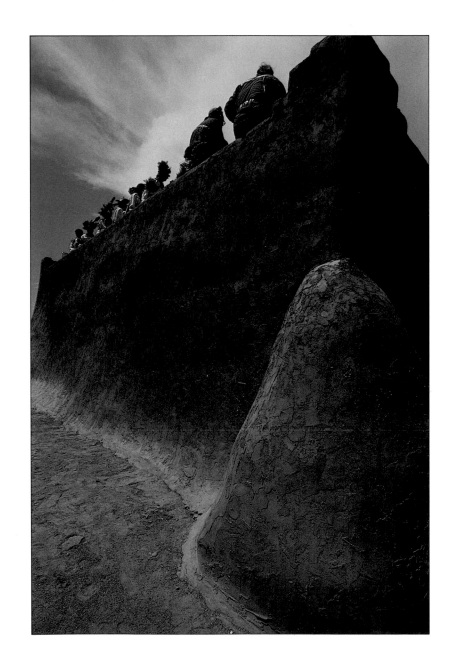

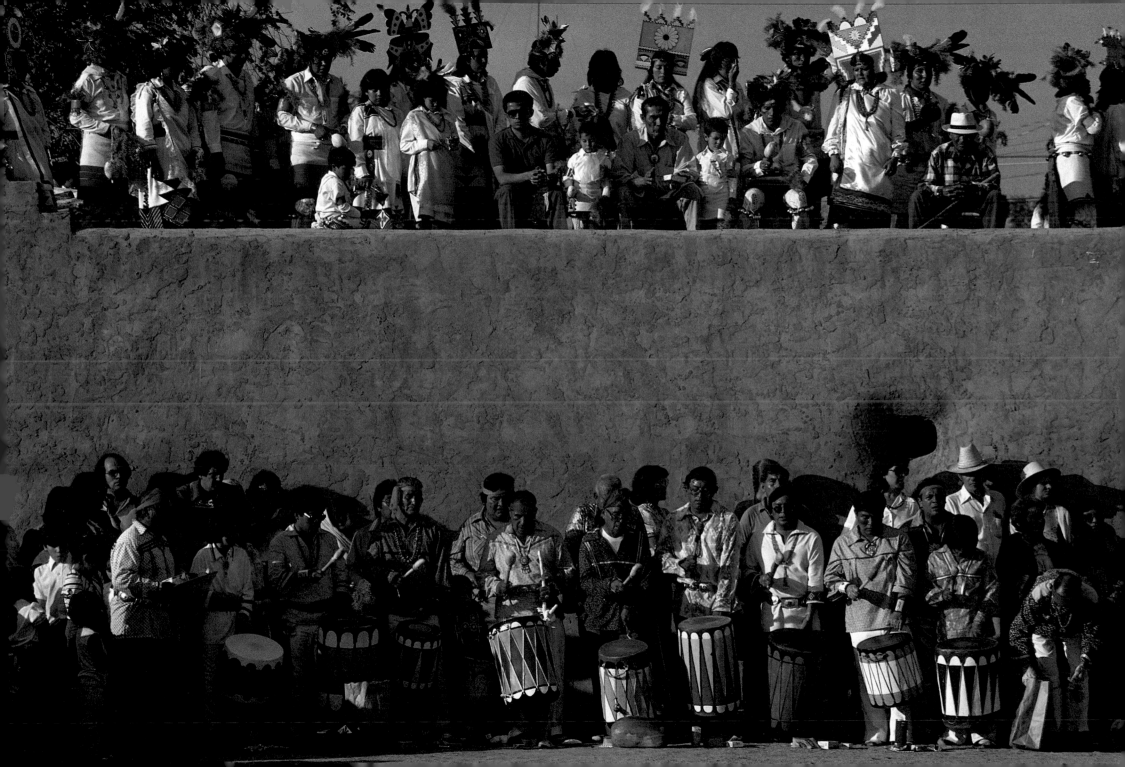

Monarco
Matachine Dance
Santa Clara Pueblo, New Mexico

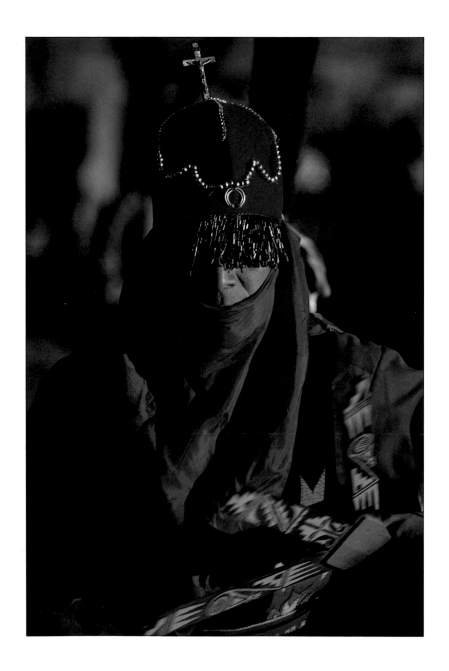

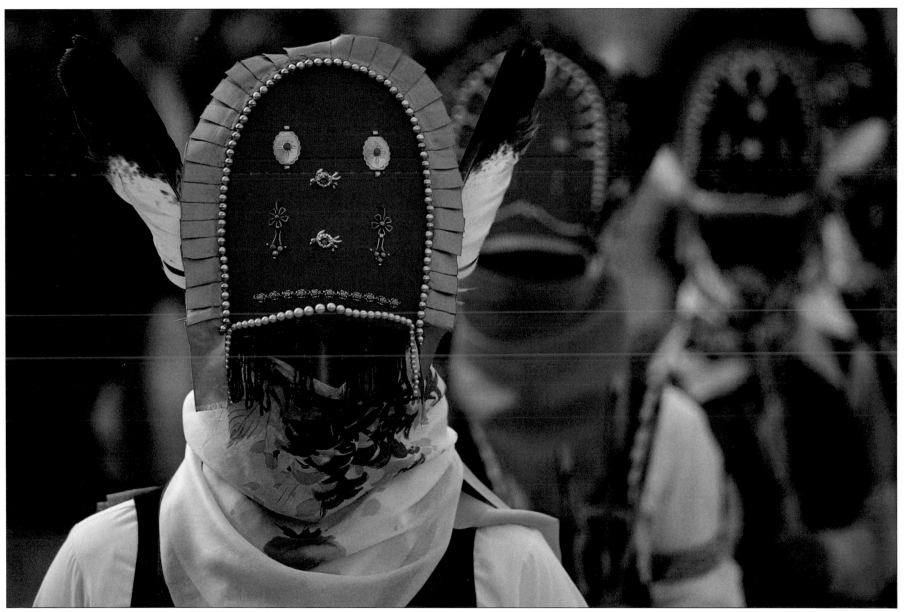

Matachine dancers    San Juan Pueblo, New Mexico

Buffalo Woman
Animal Dance
Tesuque Pueblo, New Mexico

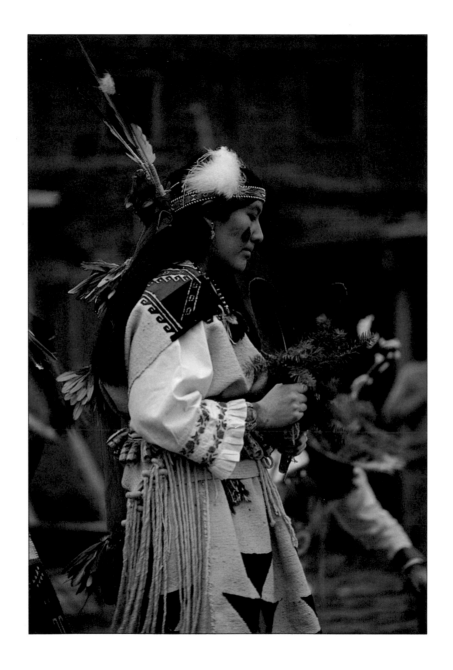

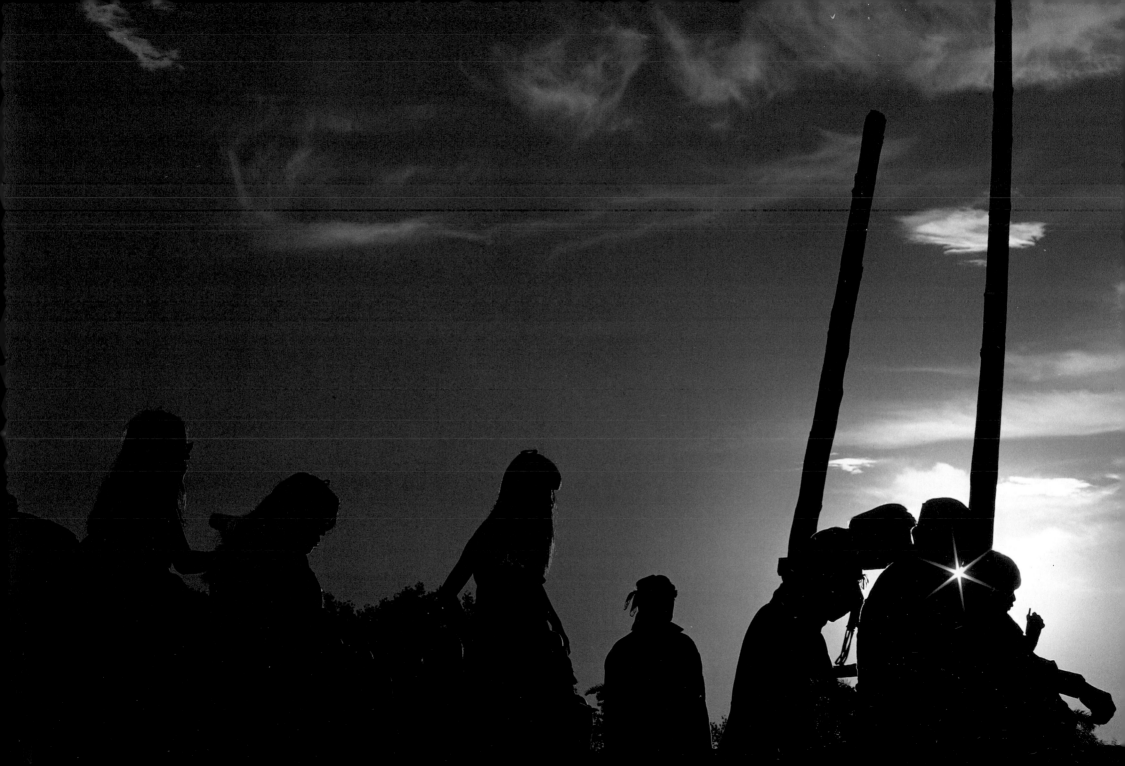

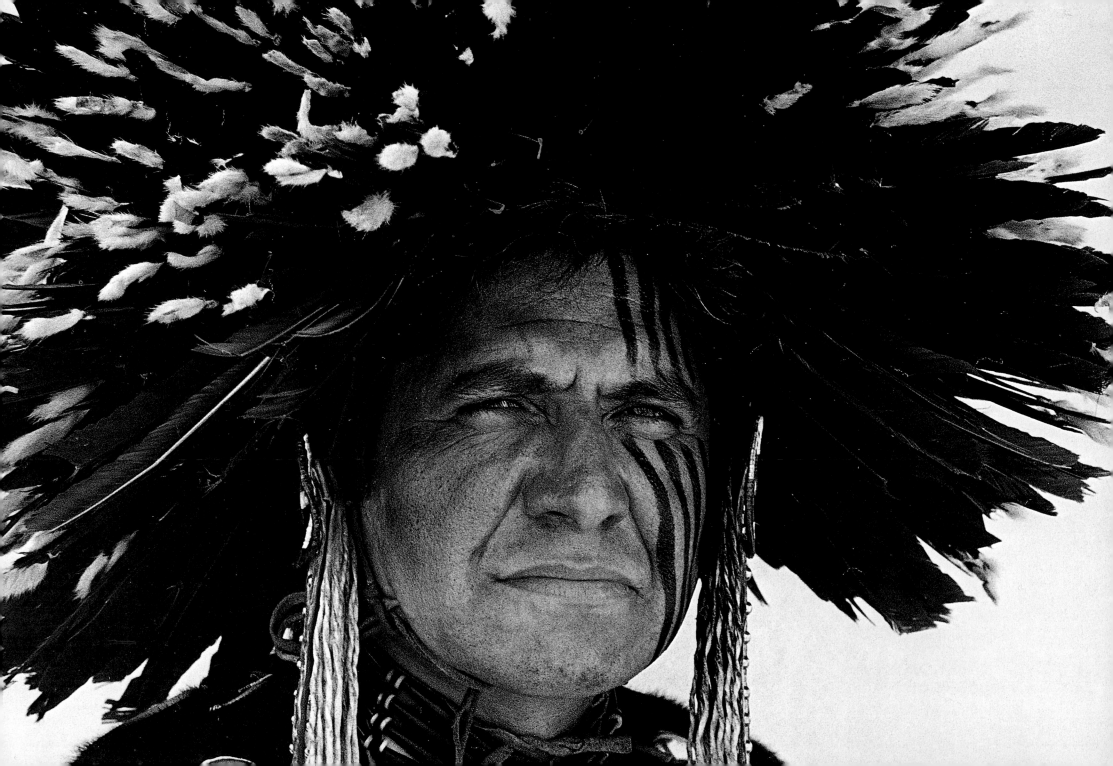

# FOUR NORTHERN PLAINS

Billy Young Pine danced differently. I wasn't sure why he stood out from the other dancers. I wondered if it was because he was so much older and, therefore, more experienced. His costume wasn't extraordinary except for his buffalo horn headdress which looked very old. Each step he made had a special spring to it, in spite of his age. I wanted to photograph Billy Young Pine of the Blood Reserve in Alberta, Canada. Later I asked him if I could take his picture. He didn't understand so I asked again, pointing at my camera. He nodded yes and spoke in a garbled way. Memory of a childhood friend came to mind. He was deaf and talked with the same thick words. Billy Young Pine was deaf. He could not hear the songs, but he could feel the drum beat through moccasin-covered feet. He felt the beat, transmitted through the ground to legs that moved with ancient grace. Billy sat for his picture. I knelt to make it and to do homage.

During the summer of 1984 I traversed the Northern Plains while on a commercial assignment. Photographer Sue Bennett was with me. We traveled in her VW bus, camped in the pow-wow grounds, and made pictures. She had a canvas awning installed on the side of the bus just before we left—an instant north-light studio. Zip up the awning, hang a backdrop, and presto! The bus became a studio. I loved it.

Traditional dancer
Assiniboine/Cree
Fort Belknap, Montana

There is something special about doing portraits in a make-shift studio. Other photographers have done it in the past and I can understand why. The portable studio defines a tiny territory, provides a background that is nowhere in particular, a space not the subject's, not mine. It is a neutral place where two people interact briefly to make a picture. Pointing at the lens I ask people to look at me, right here. We can make eye contact, we can touch each other even through this machine. The background is the same, but everyone I photograph is different, everyone is his own distinct person, his individuality is apparent. It just can't help appearing.

Billy Young Pine
Blood Tribe
Stand Off, Alberta

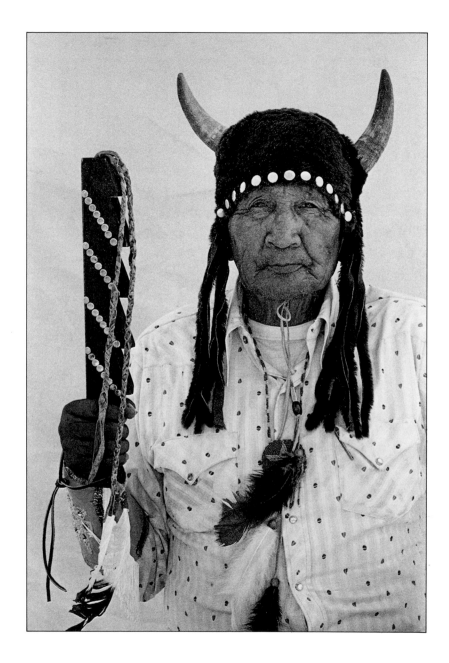

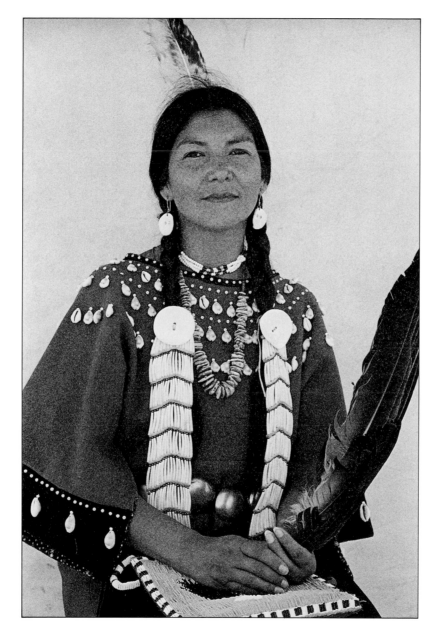

Traditional dancer
Lakota Tribe
Fort Berthold, North Dakota

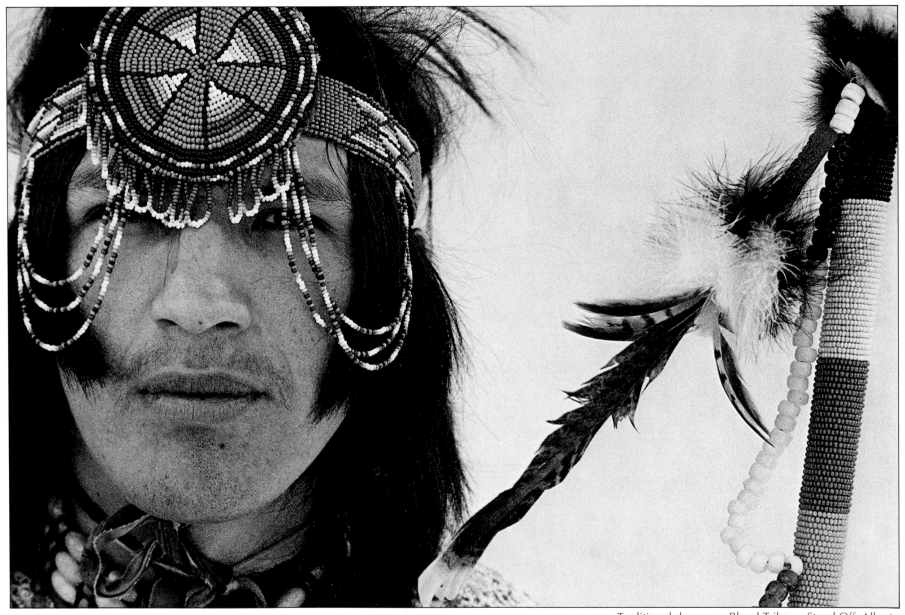

Traditional dancer    Blood Tribe    Stand Off, Alberta

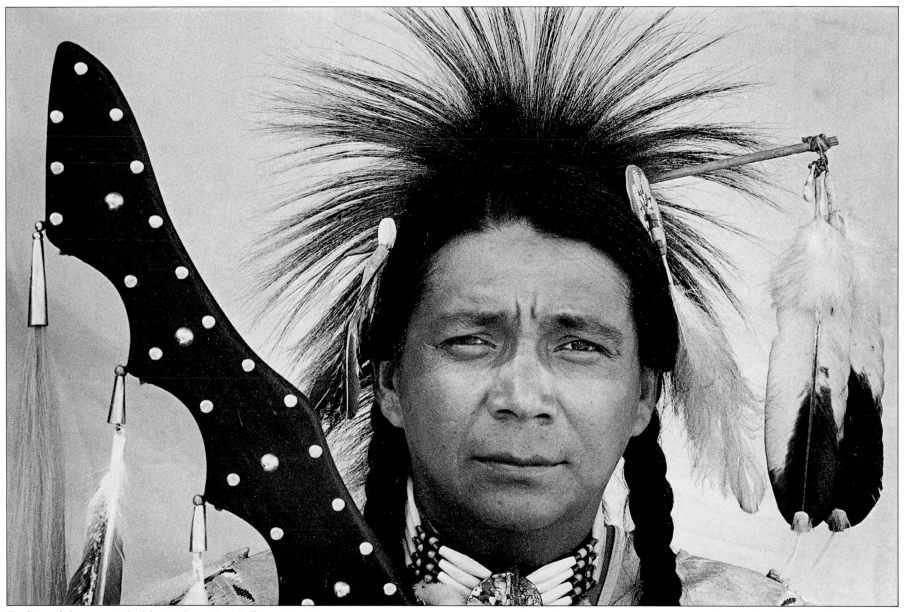

Traditional dancer     Blackfeet Tribe     Fort Belknap, Montana

Traditional dancers
Lakota Tribe
Fort Berthold, North Dakota

Traditional dancer
Gros Ventre Tribe
Fort Belknap, Montana

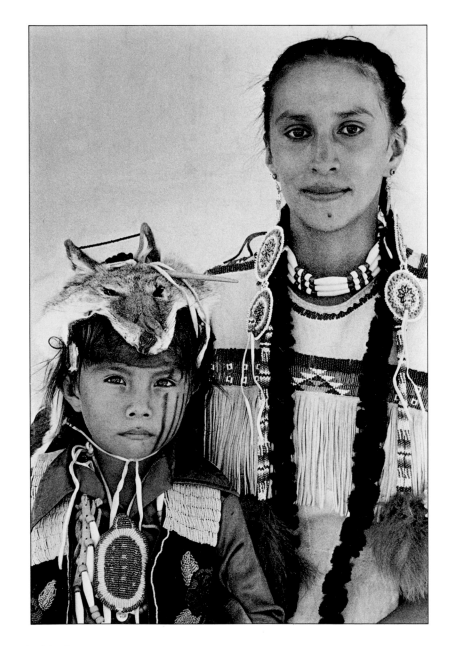

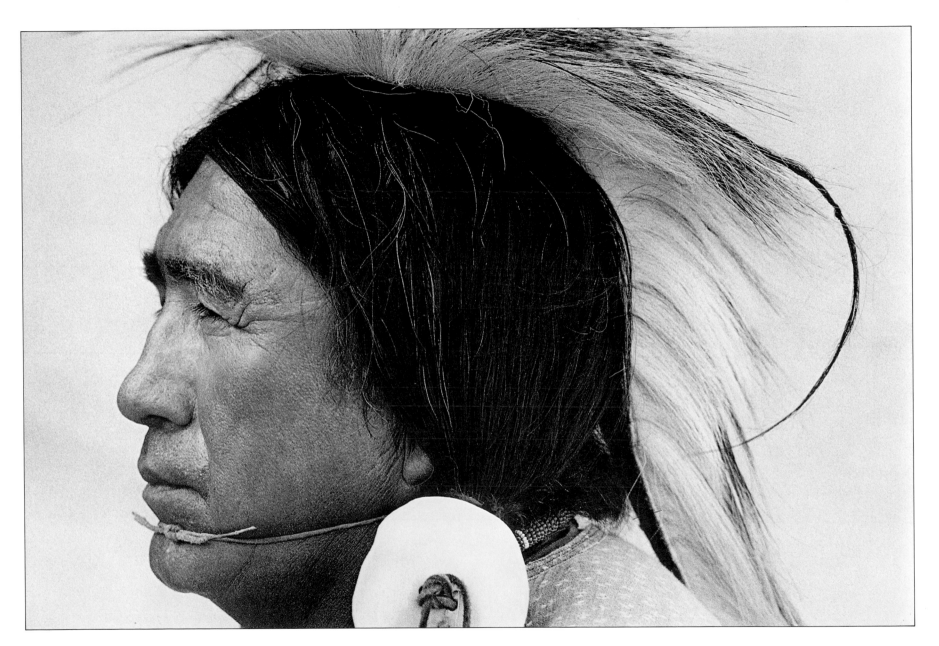

Traditional dancer
Gros Ventre Tribe
Fort Belknap, Montana

Traditional dancer
Pawnee Tribe
Fort Belknap, Montana

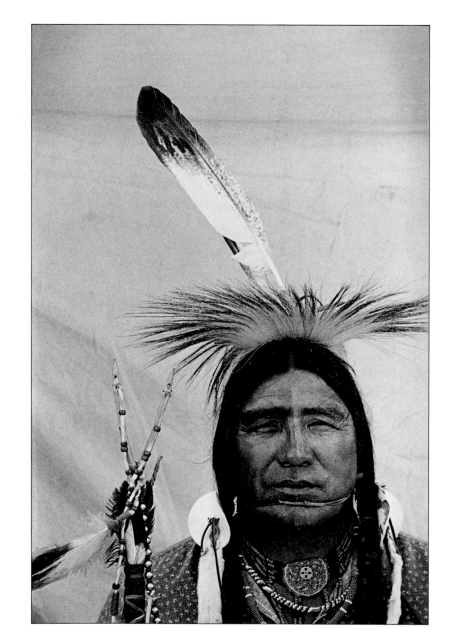

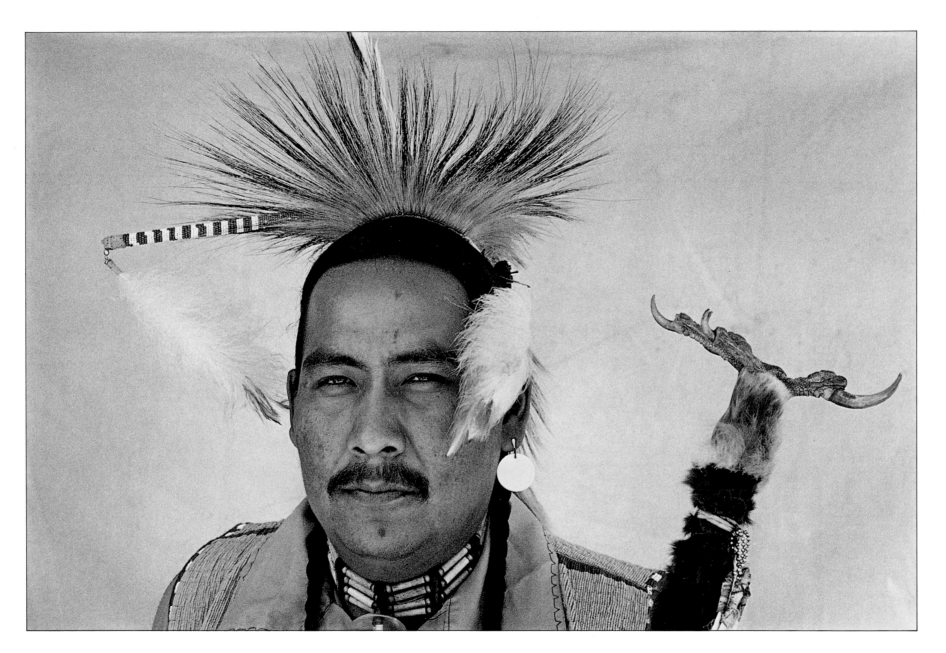

Traditional dancer
Blood Tribe
Stand Off, Alberta

Joe Buck
Gros Ventre Tribe
Fort Belknap, Montana

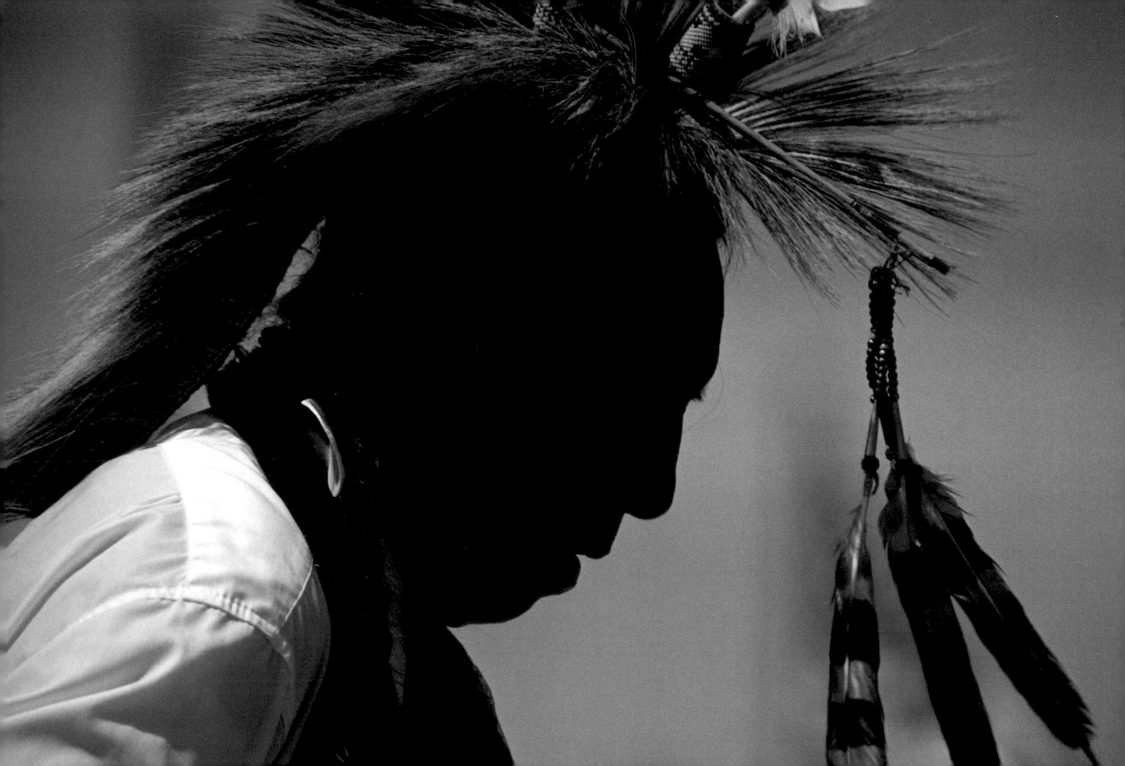

Each year the end of March, warm winds blow across the plains from the southwest. The snow melts on south-facing slopes, and the grasses begin to show green. Life returns to the Plains after the dark winter.

At the same time, Indian people take their pow-wow costumes out of pasteboard suitcases and shake out their feathers. They might add some new beadwork crafted by a grandmother during the past winter's long nights. Last summer's pow-wow songs, recorded for just this occasion, are inserted into cassette players to refresh ear, mind, body, spirit, feet. Moccasins feel better than winter boots. Buckskin is softer than heavy wool. A feather is more beautiful than a hat. With spring, the pow-wow season returns to the Plains.

Most non-Indians don't understand pow-wows, which are special occasions for Indians, by Indians. In its simplest definition, a pow-wow is a social gathering. Indian people gather to dance, to sing, to give honor, to share meals, to visit old friends, to make new friends and to reconfirm their Indian values. Pow-wows are usually held annually on many reservations. People will travel from celebration to celebration all summer long. The camps are polyglot places comprised of everything from traditional tipis and wall tents to hi-tech domed tents and recreational vehicles. People usually camp in the same place year after year.

Traditional dancer
Fort Berthold, North Dakota

Imagine a pow-wow ground from a ravens-eye view (ravens always seem to gather at pow-wows just as they used to congregate at the buffalo hunting camps). You would see a series of concentric circles. The dance area in the center is bounded by a larger shaded circle called an arbor, made of posts and covered with plywood or sometimes cottonwood boughs. There are openings at each of the four directions, and an announcer's booth most often is located on the west side. This again is circled by a wide area for foot traffic, which is bounded by another circle of food stands and sale booths. All of which is surrounded by the camping area, which has no real boundaries, but diffuses into the coulees and plains.

I first photographed Plains Indians nearly fourteen years ago. I was traveling through Browning on the Blackfeet Reservation on my way to Glacier National Park in Montana. A huge encampment of tipis on the north side of the road caught my eye. I pulled over and stopped. There was a pow-wow going on—men in eagle feather warbonnets, women in cream-colored buckskins, young men wearing the brilliant feathered bustles of fancy-dancer costumes, girls wearing the bright, shiny satin dresses of fancy-shawl costumes. Drums throbbed. Singers wailed. A bend in the highway led to a moment in the past, yet this event was very much in the present.

I was accustomed to working in the Southwest where, more often than not, the Indian people do not allow photography. So I went into the pow-wow area without my camera and asked a man in a fancy-dancer costume if I could take pictures. "Sure," he replied. "Everyone takes pictures." I stood there just looking and absorbing when an old man wearing eagle feathers and white buckskins came up to me and said, "When you take pictures, take pictures of the young women. They are so beautiful. Take pictures of them and you will remember this place better."

With his advice very much in mind I returned to my car, picked up my cameras and took pictures of everything—of the old men who danced and then fanned themselves with eagle wings, of the old women who danced in place the traditional way so the long fringes on their buckskin dresses embellished their graceful bobbing movements. The young men in brilliant fancy-dancer costumes strutted about between dances, but when they danced they showed both grace and agility with an athletic prowess.

The adult male traditional dancers looked so different, like warriors from the past; they didn't wear the brightly dyed feathers. Their costumes were more subdued, subtle. They carried a weapon or coup stick and told stories with their dance. They were looking for an enemy, following tracks, dancing quick, stealthy steps, low to the ground. They searched with darting eyes that never rested, then found the enemy and went forward, only forward, never a step back in retreat. Their dance had the stylized movement of an animal, alert and cautious like a deer that knows he is being stalked, yet incorporating the fluidity and grace of a mountain lion that knows he is going to kill.

The young women also had two styles of dancing. Like the male fancy dancers, the women fancy-shawl dancers wore costumes with dazzling colors. Their dance was athletic. They danced and spun on pumping legs. They seemed to have magic

moccasins on their feet that almost made the dancer lift off the ground and fly. Once I think I heard the fringes on their shawls crack like a whip.

In contrast, the young women traditional dancers dressed in earth-toned hues, creamy buckskin, brown otterskin, the red of a flicker's feather. Their dance style showed absolute composure and dignity as they stood off to the side. They dipped their knees a little deeper than the older women, making the yard-long fringes of their dresses ripple like wind-blown reeds along a river. When the drum beat an emphasis, they shaded their eyes with eagle-feather fans held by cut-bead handles. I wondered what they saw, watching all the dancers through their Indian eyes. I made pictures with my camera eyes, especially of the younger women. And like the old man said, I did remember it well.

The pow-wow announcer tries to maintain the schedule of the day's events, beginning in the morning with the flag raising. Family give-aways usually take place during the afternoon, sometimes followed by gourd dancing. Then, about the time the sun gets low in the sky, but long before it sets, the announcer will start to call for the grand entry. "OK you dancers out there, it's time to get ready. We are going to start at seven o'clock sharp. You drums, get over here and get your speaker systems set up. Houka Ho! Houka Ho," the announcer calls in the old way. The camp ignores him. Soon he exhorts, "You drums better get over here if you want to be counted for the prize money." Next he cajoles, "You dancers better line up for the Grand Entry. We have lots of visitors and we should show them that we do things on time here." Eventually everybody is ready, the dancers are lined up and counted, the veterans unfurl flags, the eagle staff is held high. Everything is ready, poised, waiting for the first drum beat.

The drums provide the heartbeat of the pow-wow. A group of singers sit around their single drum and beat and sing in unison. Collectively both singers and drum are called "a drum," and they have names like The Porcupine Singers, The Sacred Mountain Singers, The Bay Area Singers, Good Land Singers, Hays Singers. The leader of the group will start the beat and "push up" the song, which is usually sung in vocables, word-like sounds that do not have specific meanings. Honor songs and flag songs are sung in the drummers' native language. The high-pitched falsetto wail of the leader, followed several beats later by the group, makes a music that takes the dancers back to a time when buffalo hunters still ruled the Plains. The old aboriginal heart throbs in everyone, their Indian hearts still pump red blood.

Honor Guard
Browning, Montana

Pow-wow camp
Rocky Boys, Montana

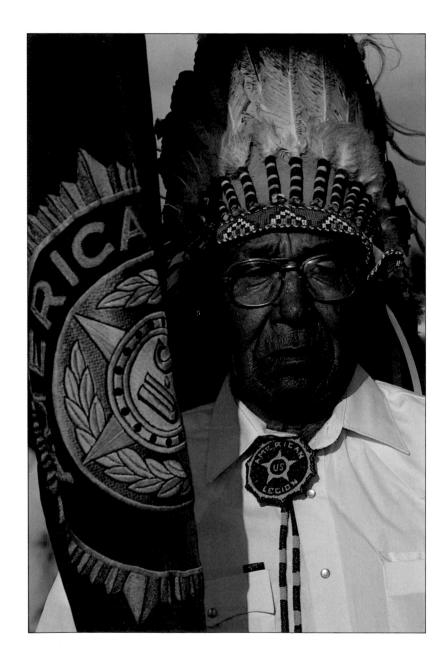

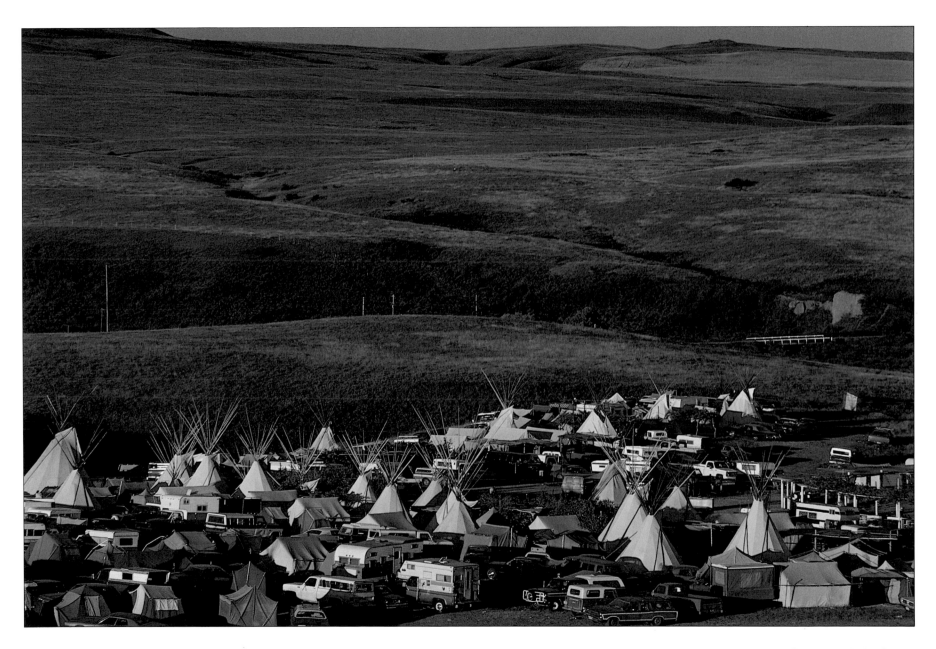

Honor Dance
Ethete, Wyoming

Veteran folding the flag
Fort Berthold, North Dakota

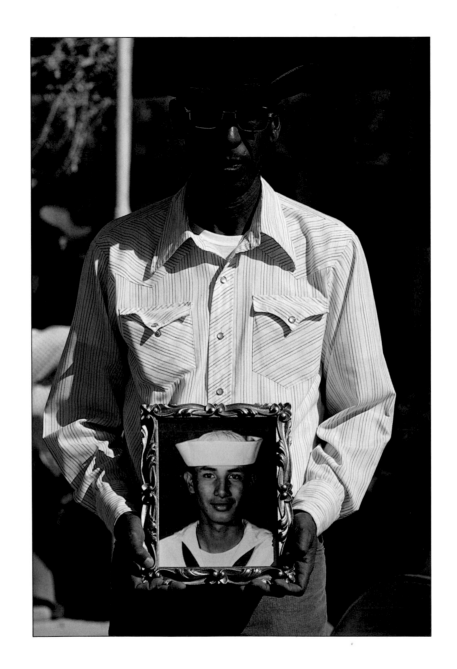

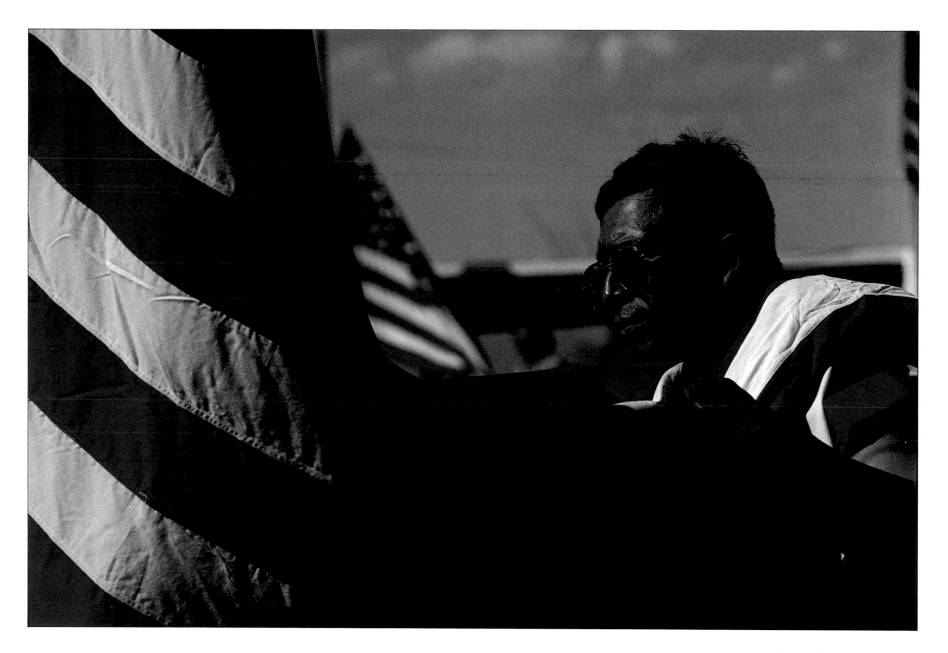

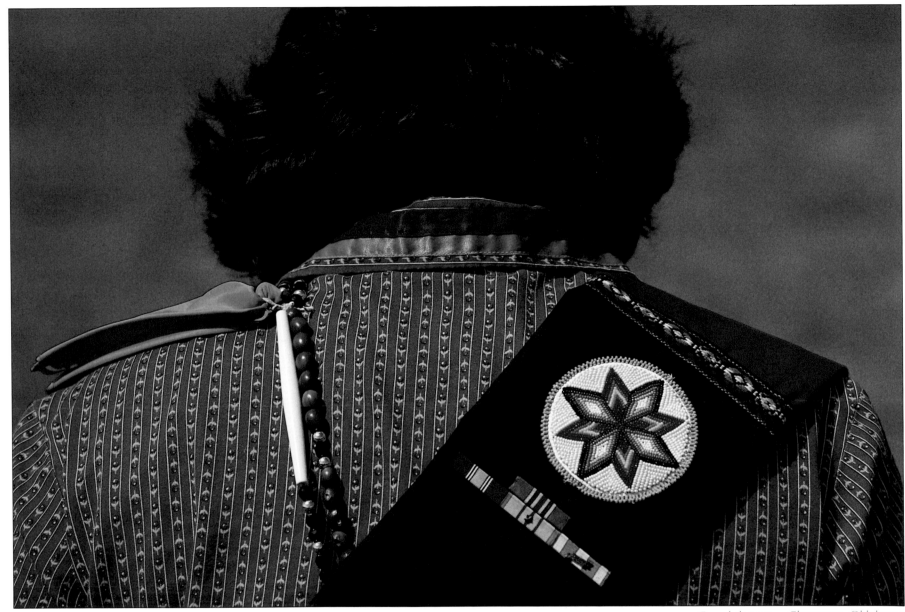

Gourd dancer    Claremore, Oklahoma

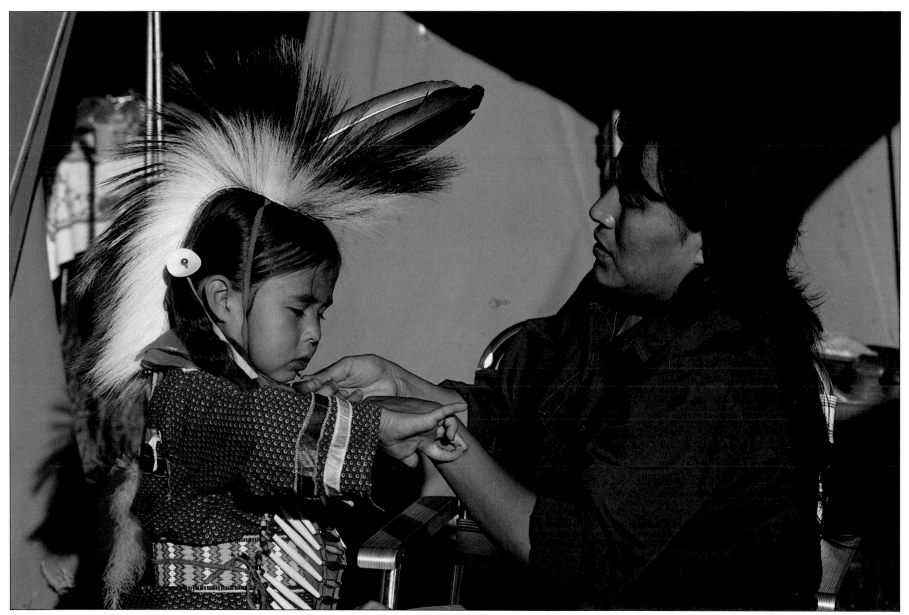

Dressing    Fort Belknap, Montana

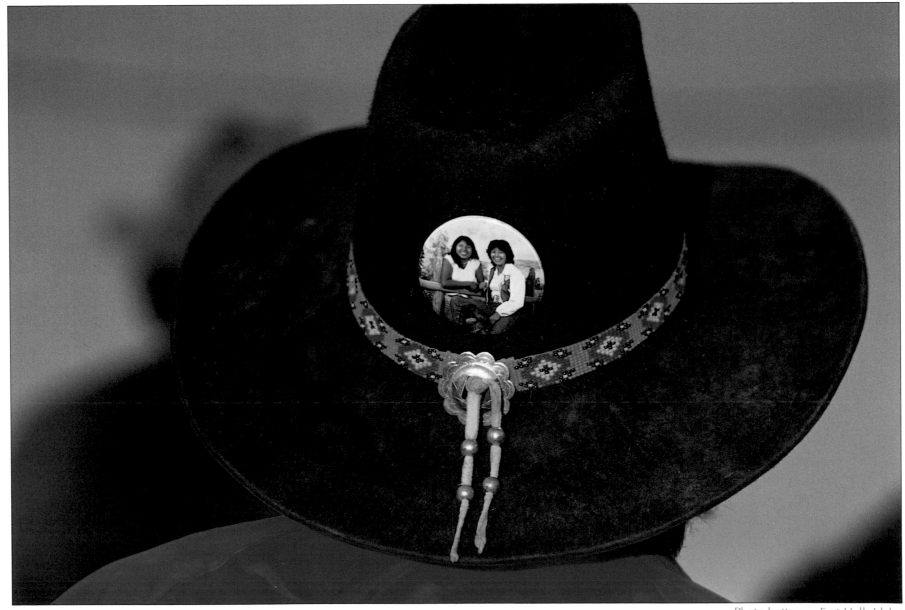

Photo button    Fort Hall, Idaho

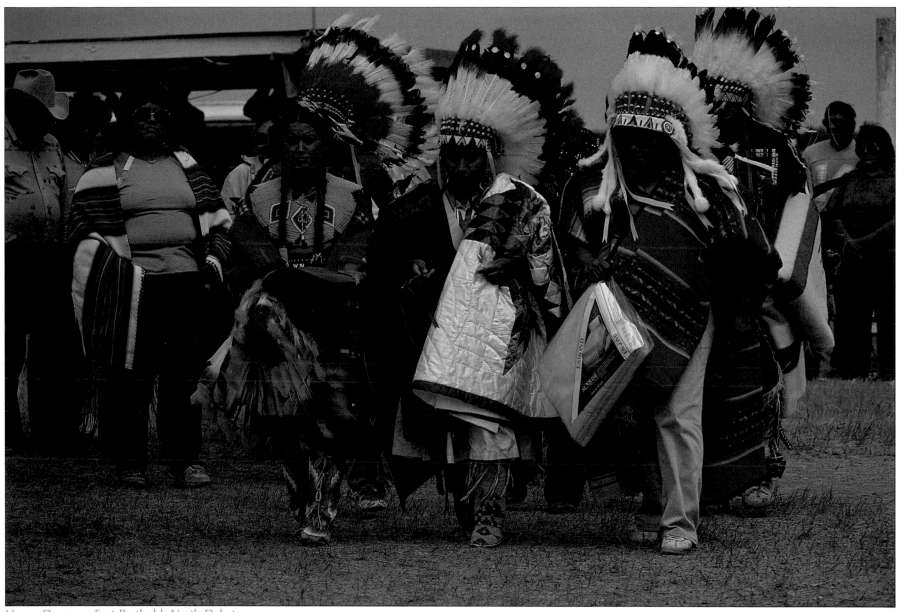

Honor Dance   Fort Berthold, North Dakota

Give-away
Fort Berthold, North Dakota

Singer
Quapaw, Oklahoma

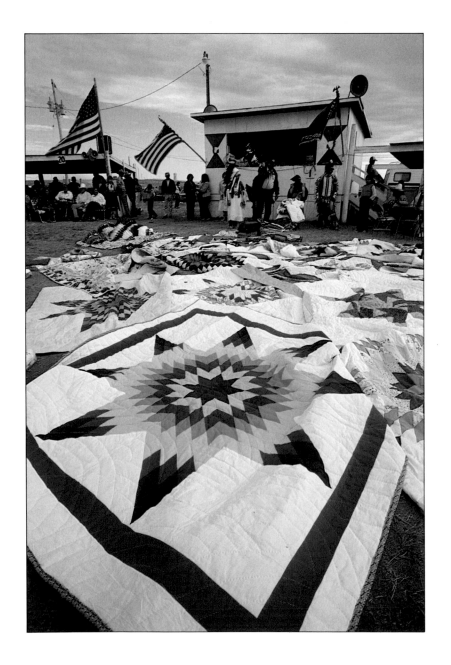

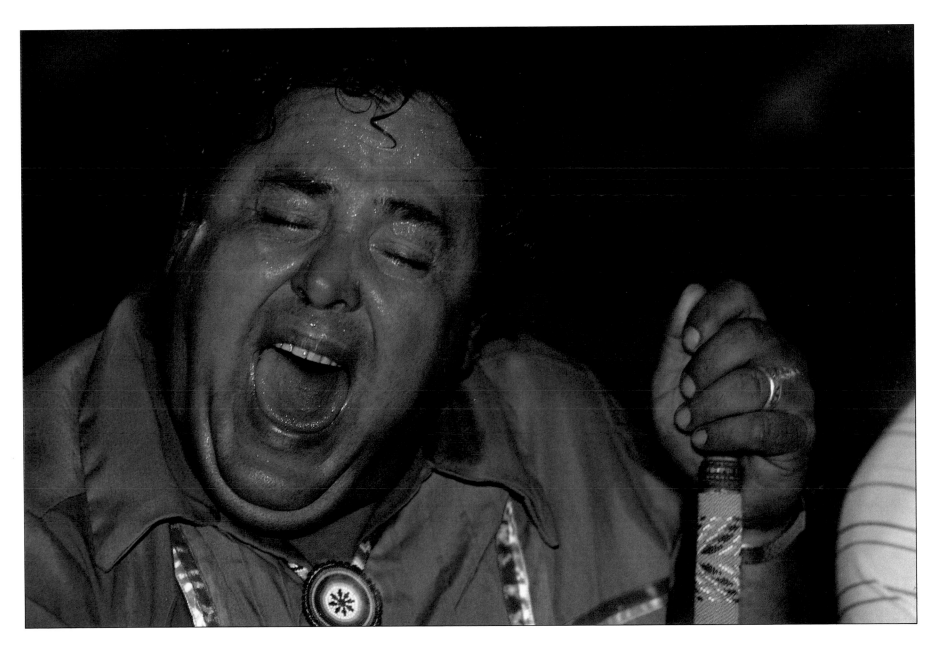

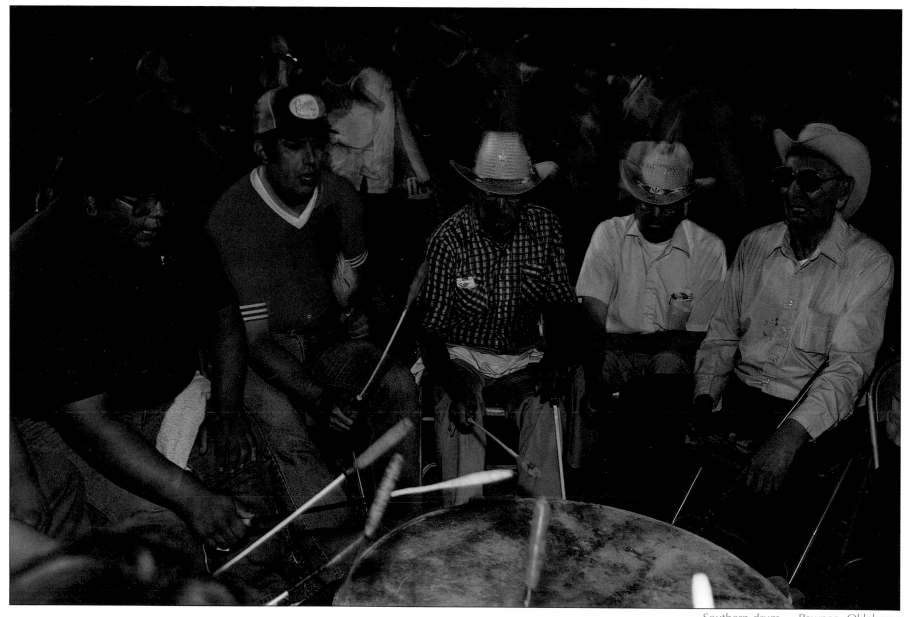

Southern drum    Pawnee, Oklahoma

Singer    Crow Agency, Montana

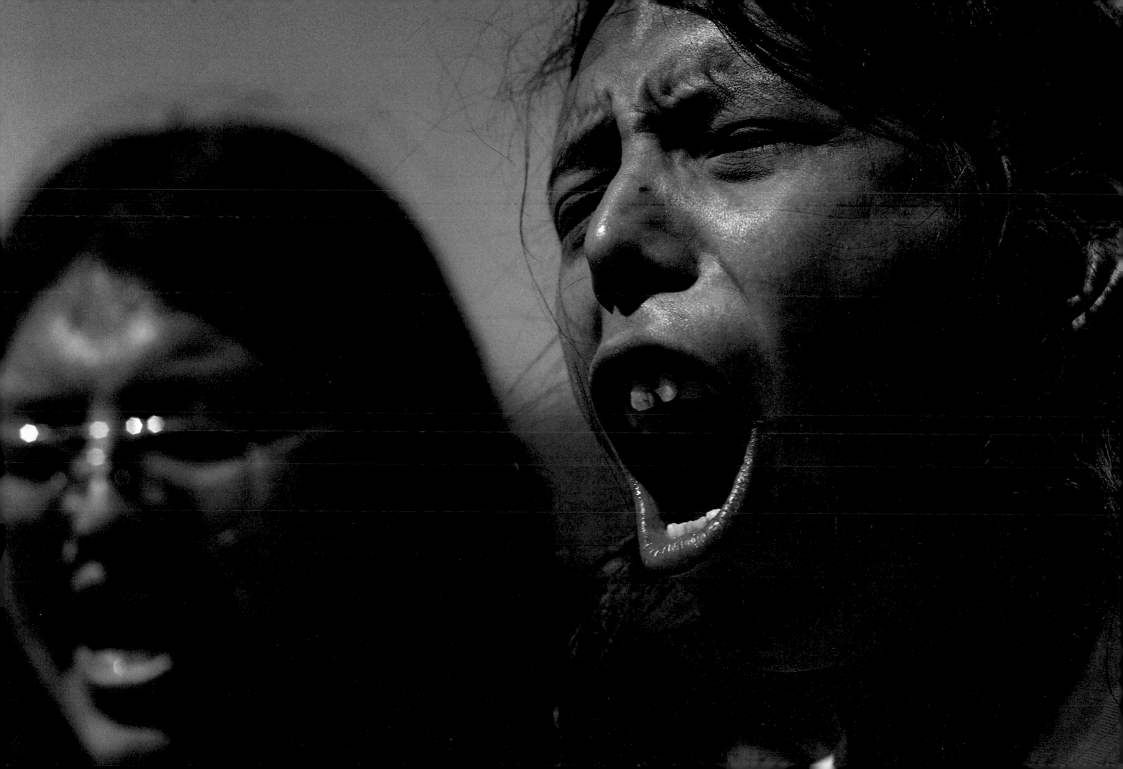

Cree woman
Rocky Boys, Montana

Traditional dancer
Rocky Boys, Montana

Traditional dancer
Fort Hall, Idaho

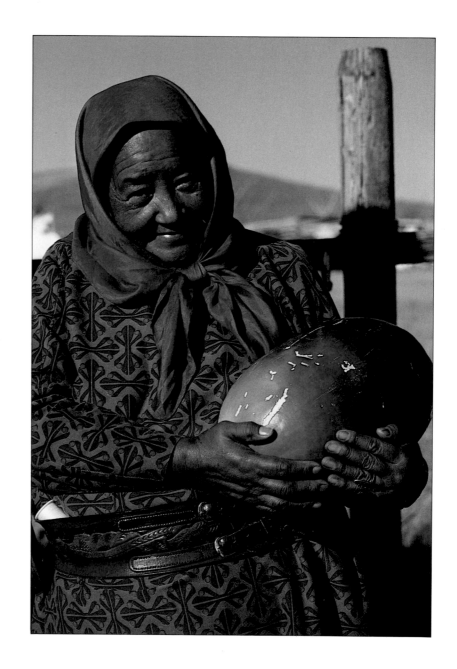

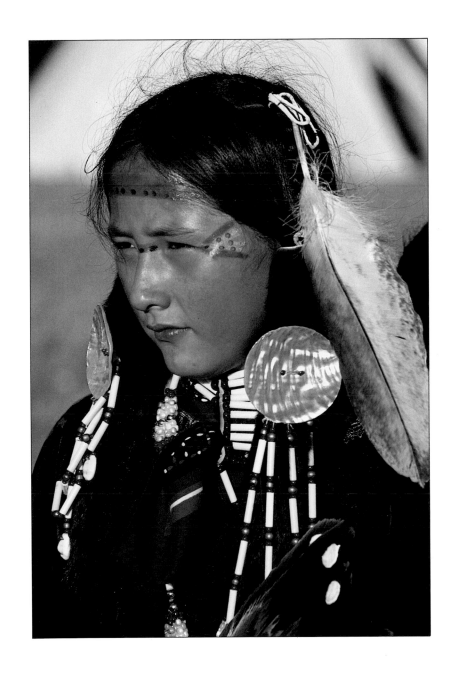

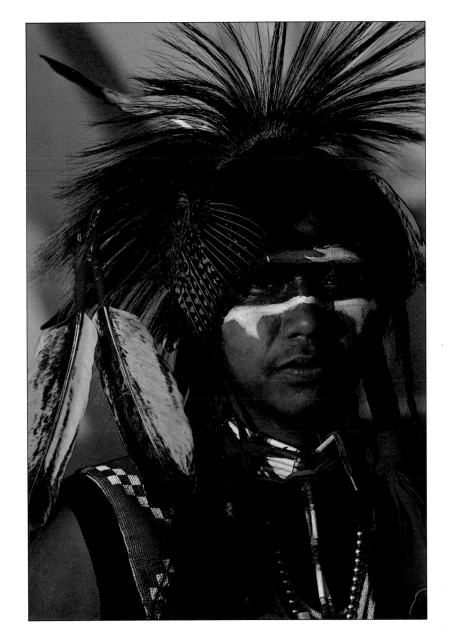

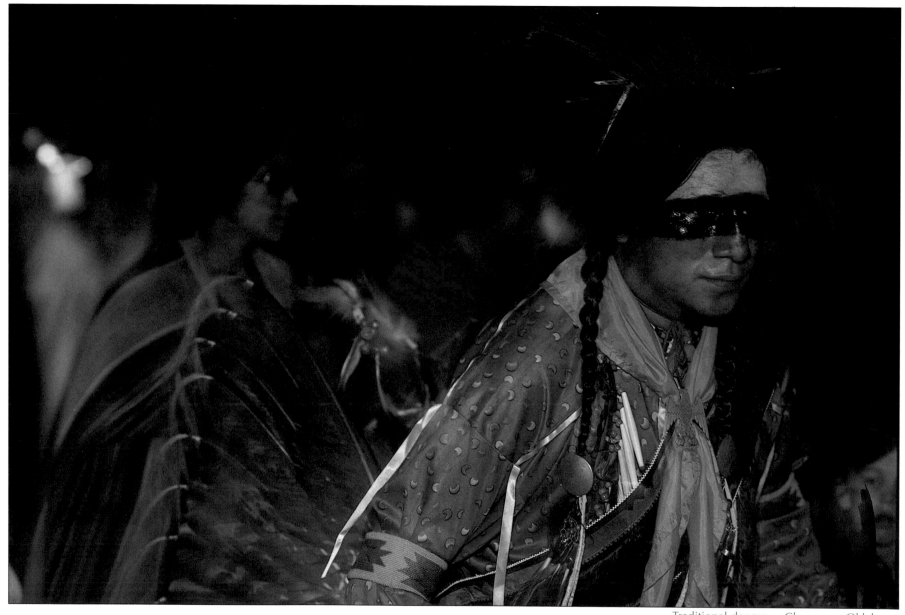

Traditional dancer    Claremore, Oklahoma

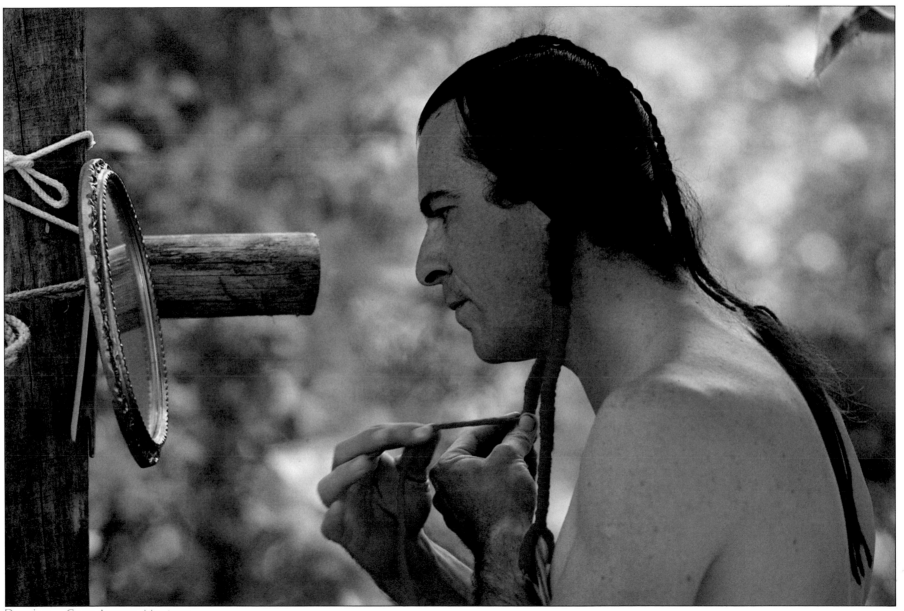

Dressing    Crow Agency, Montana

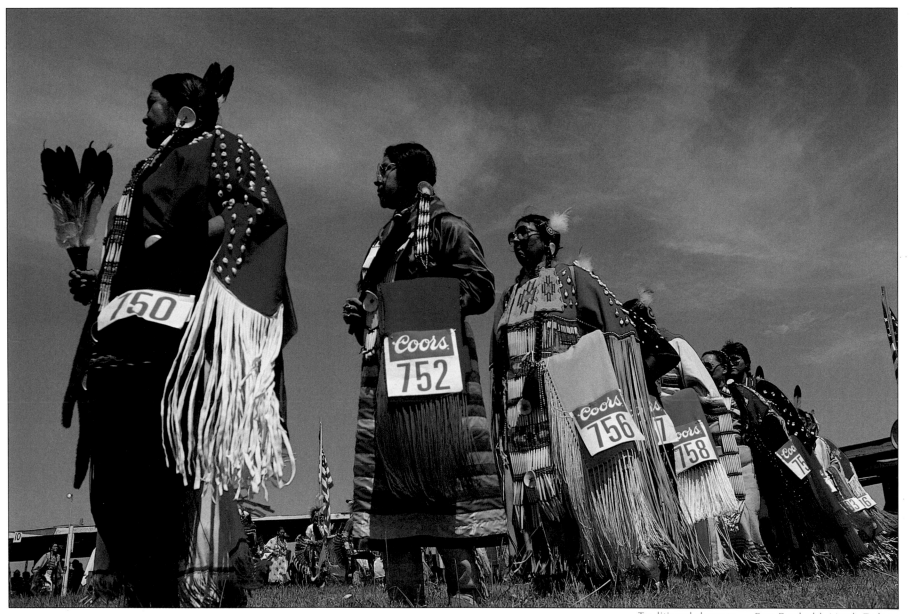

Traditional dancers    Fort Berthold, North Dakota

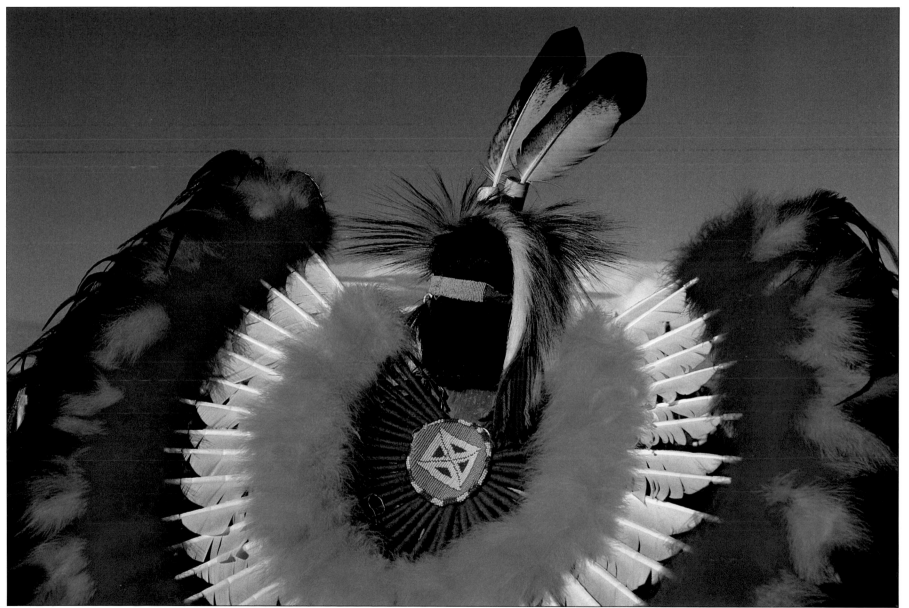

Fancy dancer's bustle    Browning, Montana

Traditional dancer
Fort Hall, Idaho

Tipis
Rocky Boys, Montana

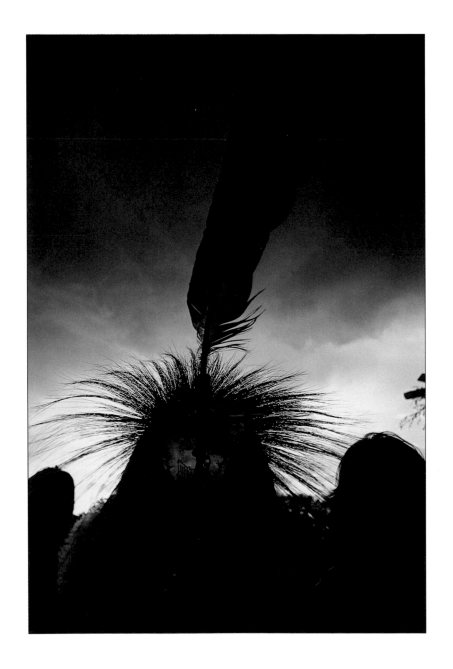

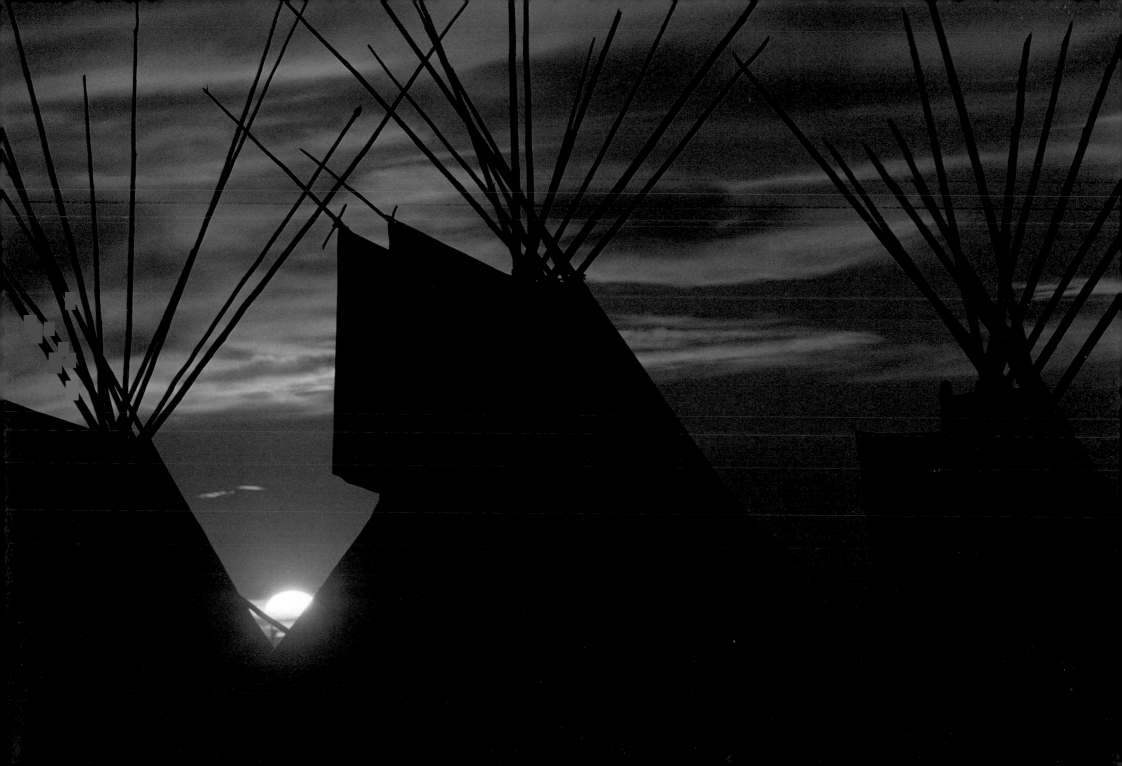

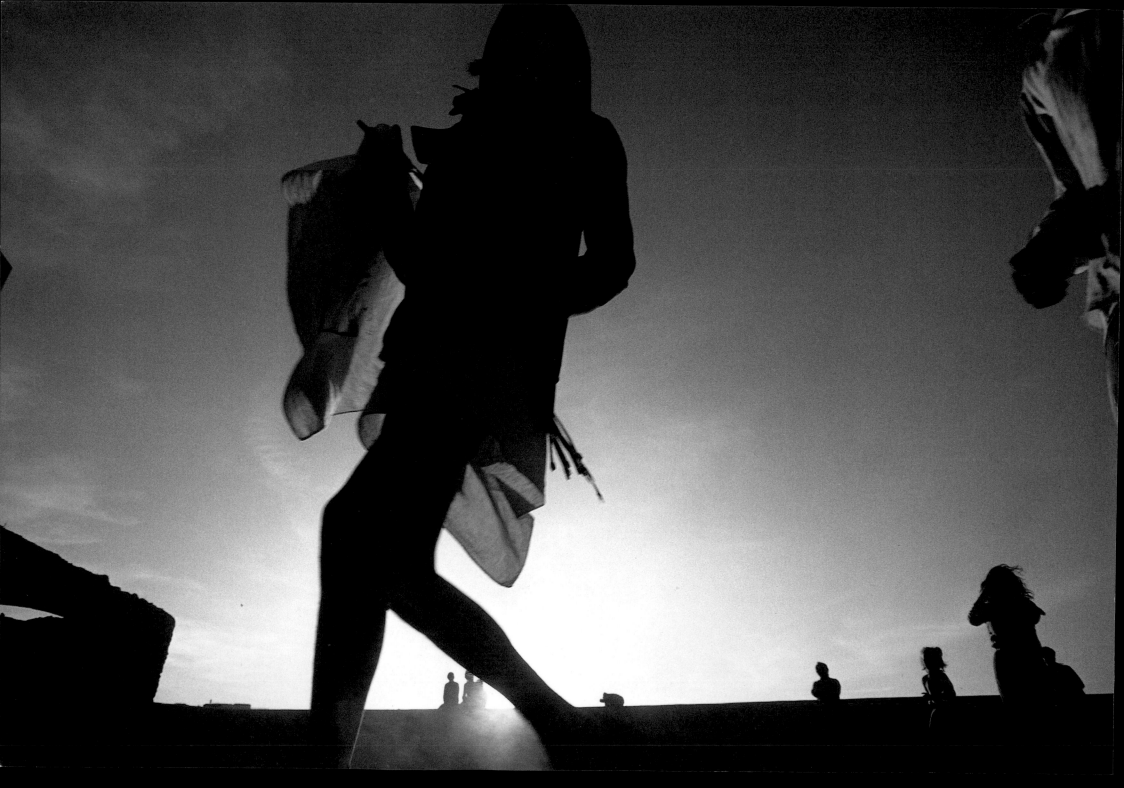

The story has been told too many times—conquest, assimilation, and disappearance. For the Tarahumara, however, there is a difference. First, their story isn't finished yet, and second, so far, the Tarahumara have not been conquered. They have not been assimilated. They have not disappeared.

Sue Bennett took me to the Sierra Tarahumara for the first time in the spring of 1980, and since then we have returned two other times. Their mountains are not far south of the Mexico/United States border—just three hundred miles south and a little east of Tucson, Arizona. There are about fifty thousand Tarahumara, making them the second largest Indian tribe in North America, second only to the Navajo.

The Tarahumara call themselves *Rarámuri*, "the people who run." Over the past four centuries, the Tarahumara people have retreated deeper and deeper into the Sierra Madre. They left their fertile plains below the mountains to escape the influences of "civilized" people. Now they have retreated as far as they can go; there is no more sierra.

Today the Tarahumara are faced with a number of difficult problems: poor farmland, poor nutrition, high infant mortality. Each circumstance precipitates the next. Most recently, the Mexican lumber industry has opened a vast new area of the Sierra Madre for logging. The railroad and a new network of logging roads will put an end to the isolation that has protected the Tarahumara for so long.

Fariseo
Sierra Tarahumara, Mexico

Change will come, perhaps soon, for the Tarahumara, and the best we can hope is that the Tarahumara will have a say in determining their own future, rather than having change forced on them.

It took a little time, but the Tarahumara made us welcome. We stayed longer than most non-Indians. We camped not too far from a well-used foot trail and continuously made huge pots of boiled coffee so we could invite people over. "Quieres café?" we would call out. More often than not our invitation was accepted. We got to know the Tarahumara people over hot cups of strong Mexican coffee, sweetened with at least three heaping spoons of sugar. Later we would meet the same people in the little village nearby. "Quira va?" we greeted each other. We stayed for two weeks, for Semana Santa, Holy Week, when the Tarahumara dance to protect the universe from evil. For two weeks we made friends and pictures.

Months later, just before Christmas, we returned to make more photographs and to hang a small exhibit of our photographs taken the previous Easter. The photographs hung in the church for the week between Christmas and New Year's. Friends told us that this was the first time anyone had ever brought pictures back to the Tarahumara, and they appreciated it, "*Tatra-va, tatra-va*, thank-you, thank-you." It was the most appreciated show I ever did. The Tarahumara looked hard and long at the photographs, and for days afterward they came by our camp to have their portraits made. It was wonderful. They would tell us how much they liked the photographs while we drank coffee. "They are very clear. Would you make me?" It was an honor to have these amazing people sit in front of my camera, to make portraits, Polaroids for them, regular film for me.

One young man, Frederico, came into our camp with a violin on New Year's Eve. At first we thought he might want to sell the homemade instrument. But this one was darkened with a loved patina. This one was not for sale. Frederico wanted his portrait made holding the violin. But the sun had just set red in a winter sky, and it was too dark to do a portrait. Could he return tomorrow? "*Mañana, en la mañana,*" he answered. The next morning, New Year's Day, he was sitting just outside the camp, waiting for us to get up, waiting to have his picture made with his treasured violin. First we brewed coffee and then made Frederico's portrait, the first photograph of the year, the first photograph of 1981.

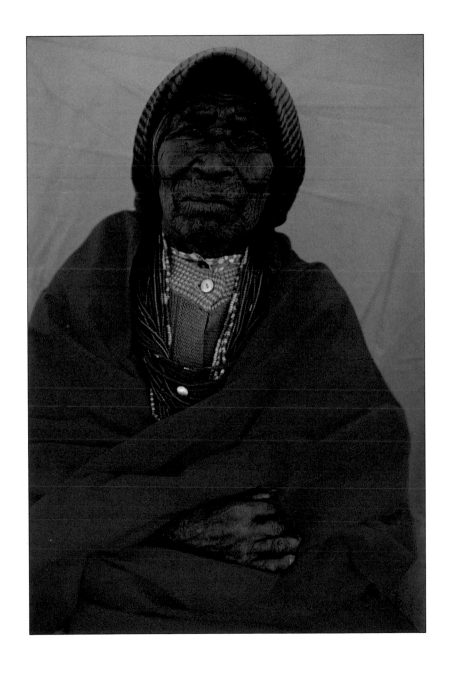

Madre de Andres, 1984
Sierra Tarahumara, Mexico

Good Friday
Sierra Tarahumara, Mexico

Palm Sunday
Sierra Tarahumara, Mexico

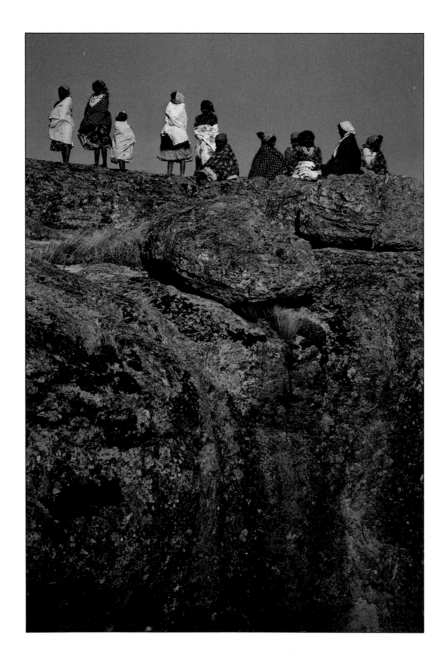

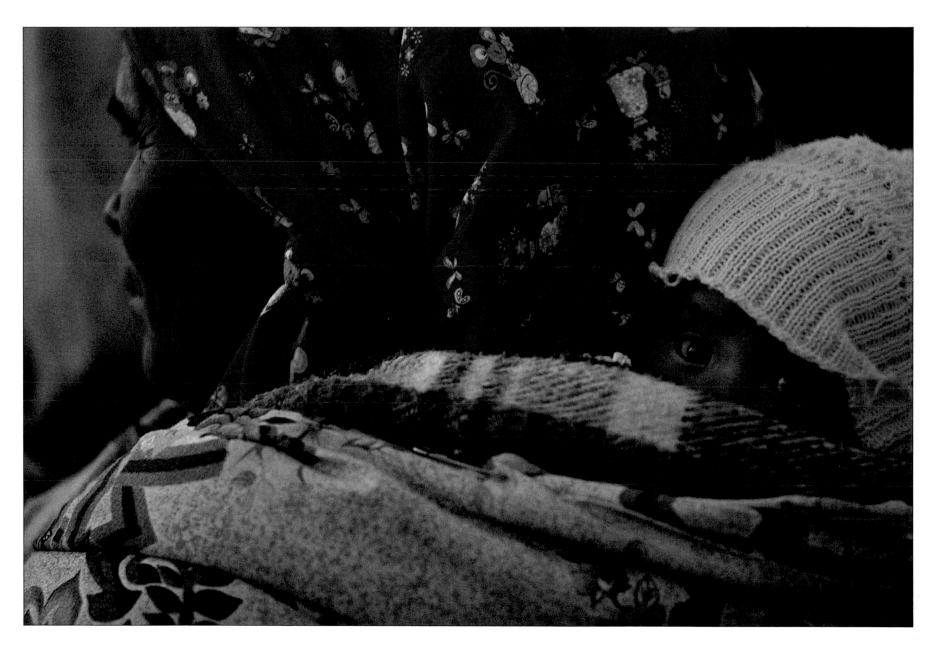

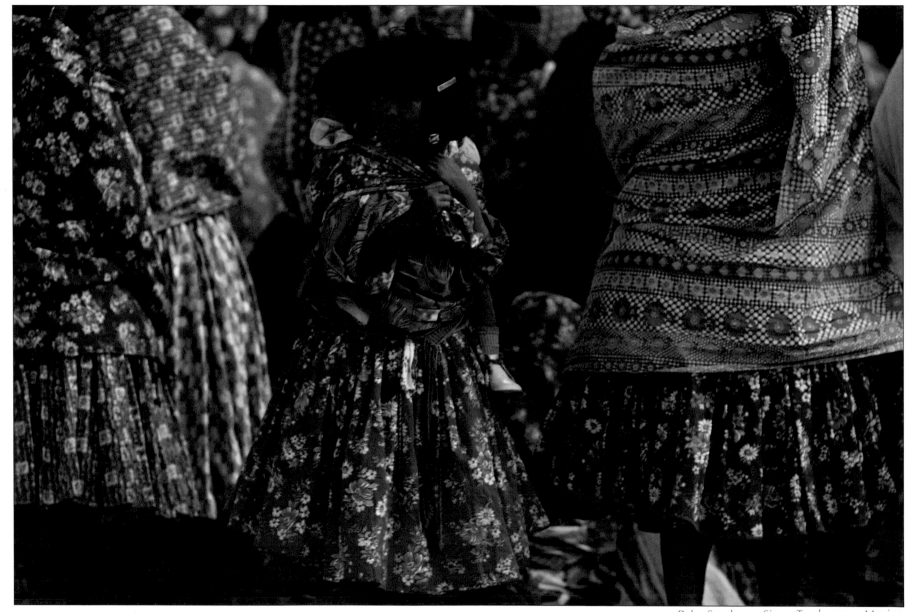

Palm Sunday    Sierra Tarahumara, Mexico

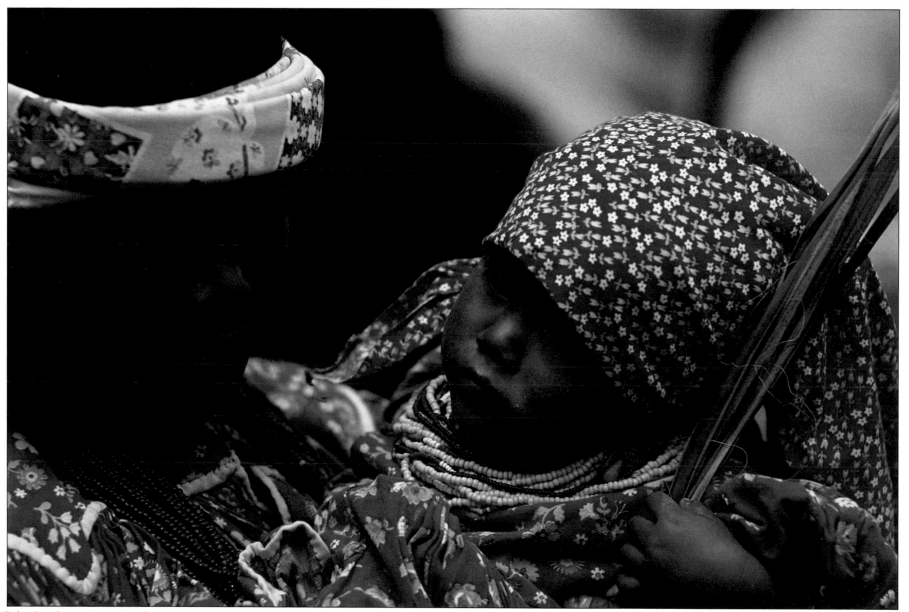

Palm Sunday    Sierra Tarahumara, Mexico

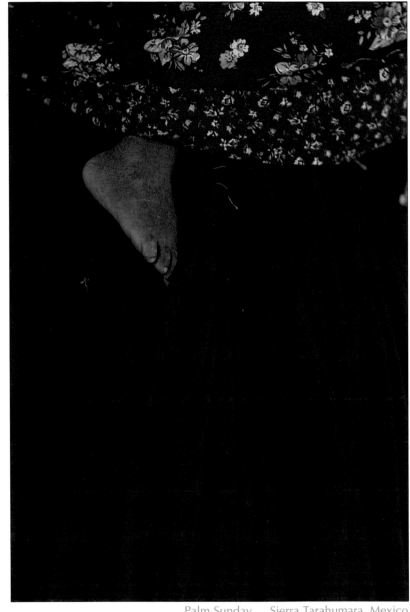

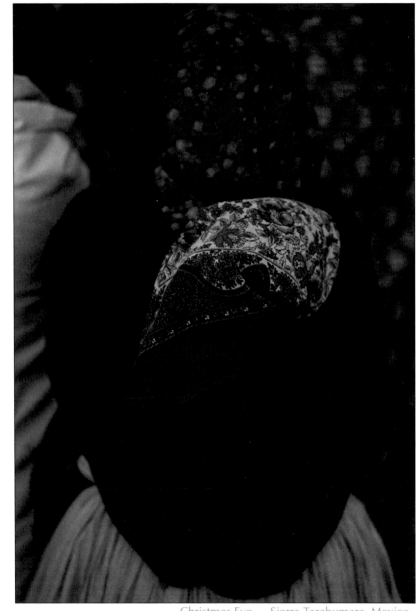

Palm Sunday    Sierra Tarahumara, Mexico

Christmas Eve    Sierra Tarahumara, Mexico

Christmas Matachines    Sierra Tarahumara, Mexico

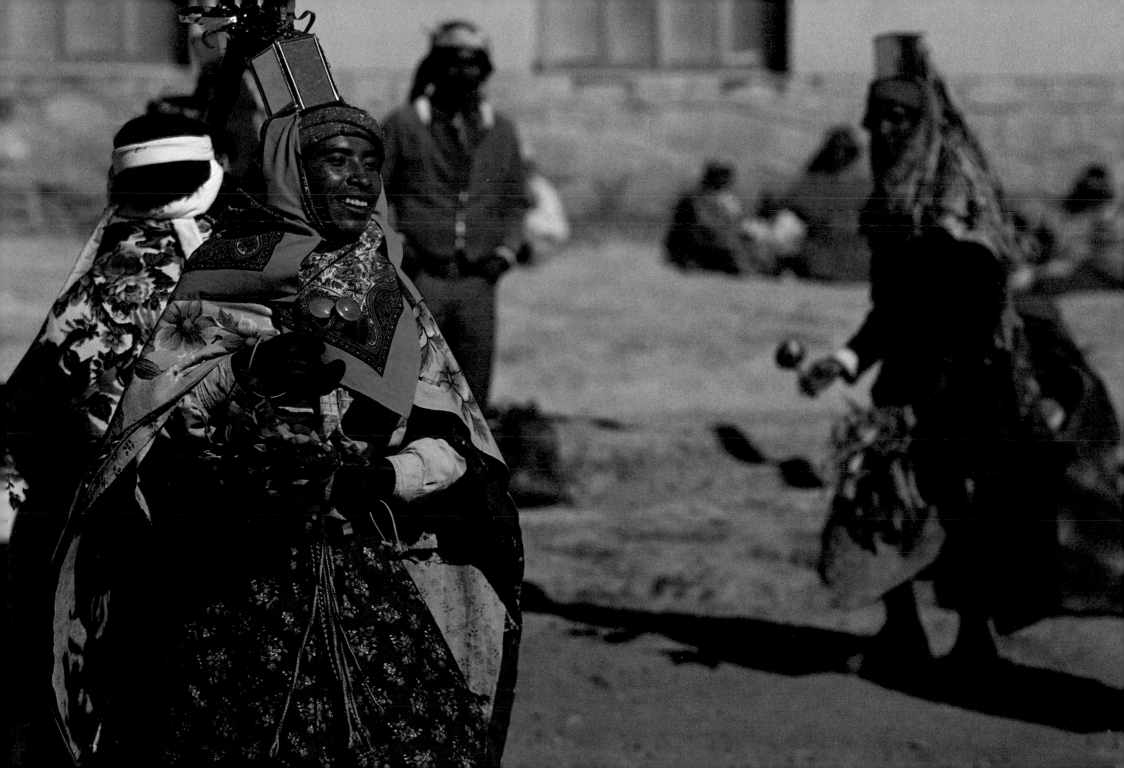

Christmas Matachine
Sierra Tarahumara, Mexico

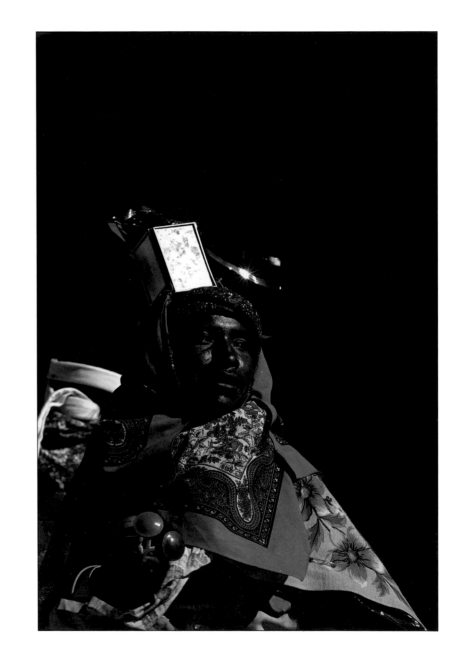

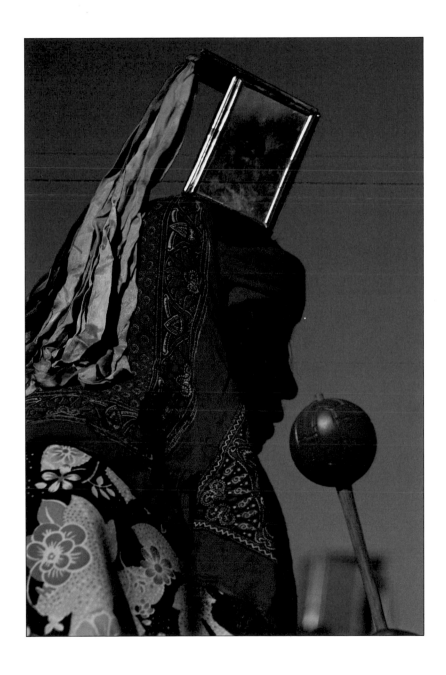

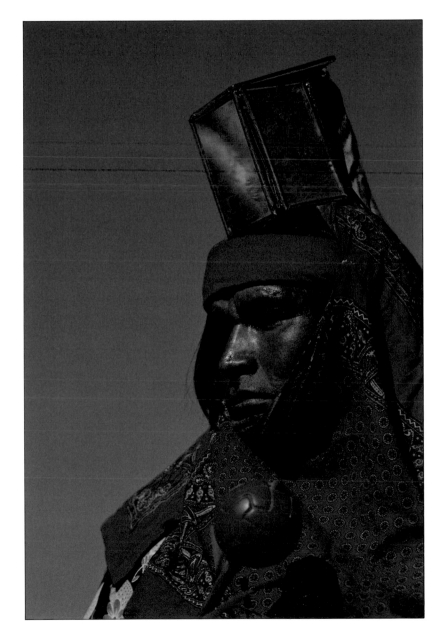

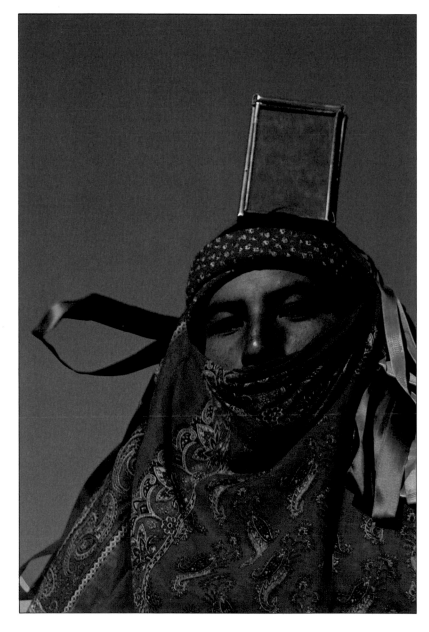

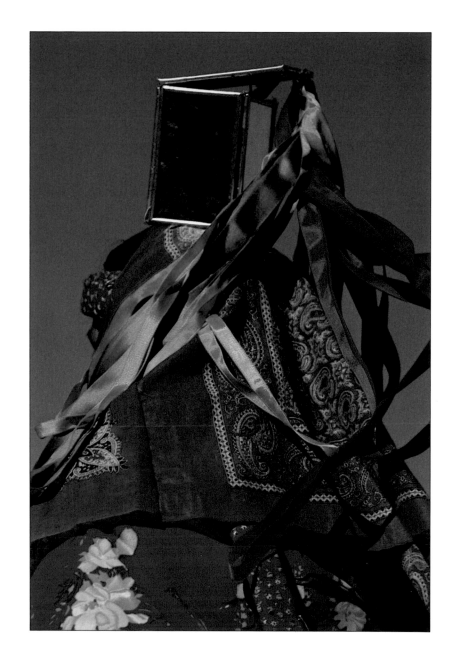

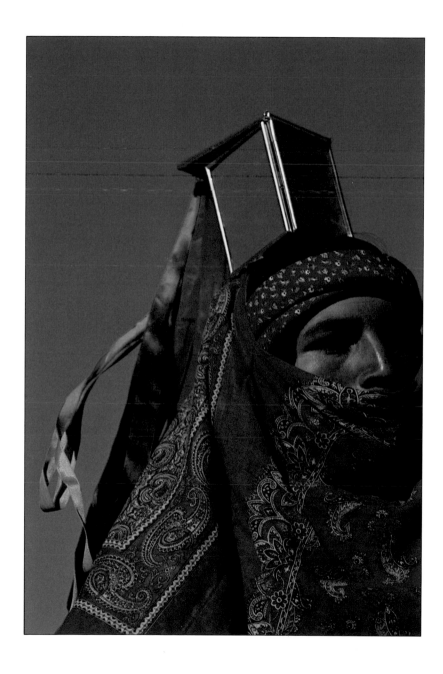

Christmas Matachine
Sierra Tarahumara, Mexico

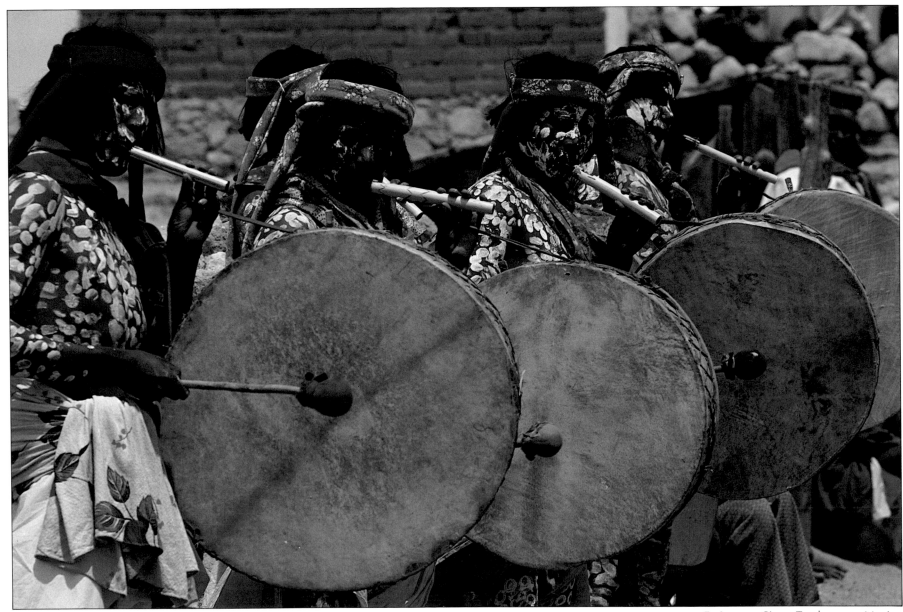

Fariseos    Sierra Tarahumara, Mexico

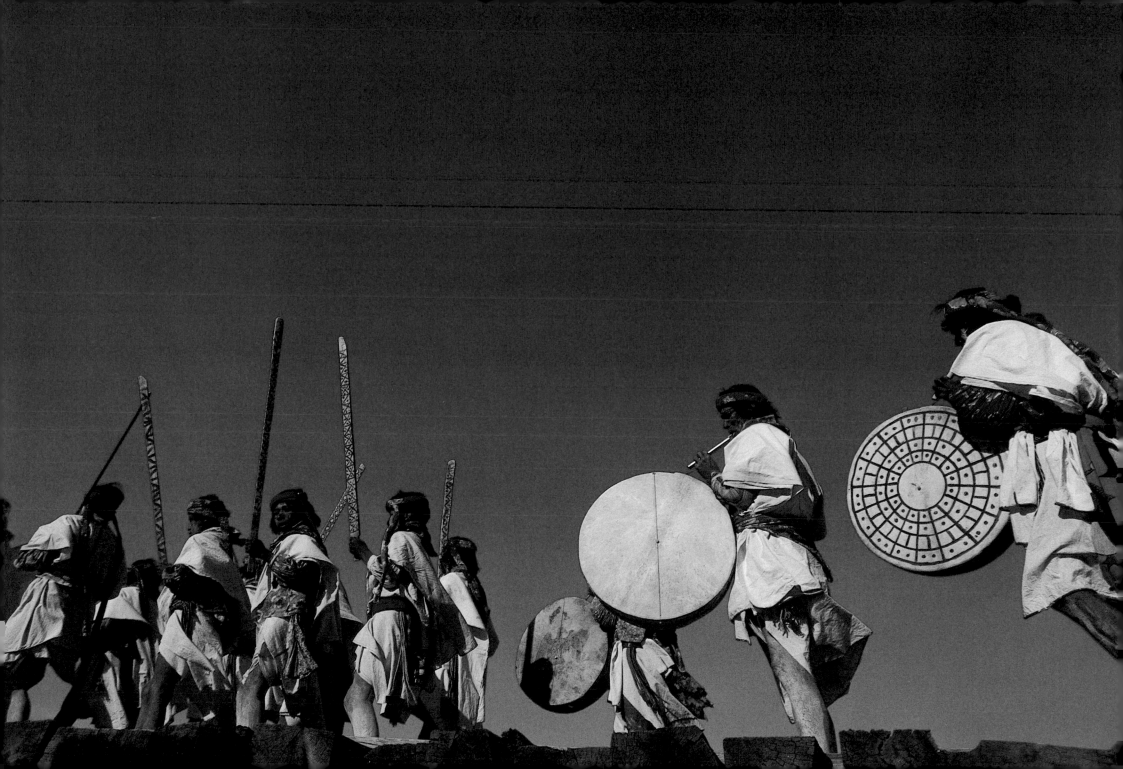

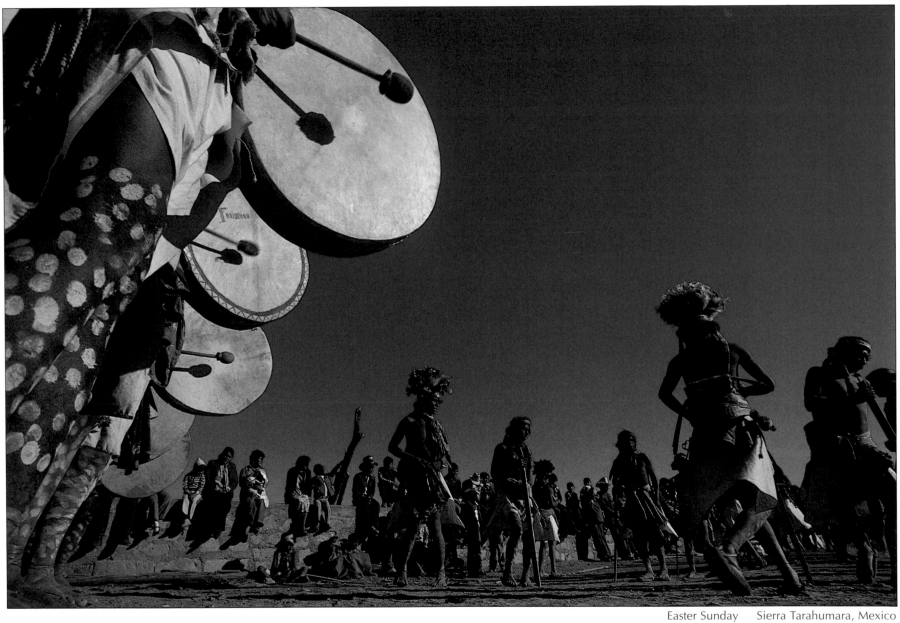

Easter Sunday    Sierra Tarahumara, Mexico

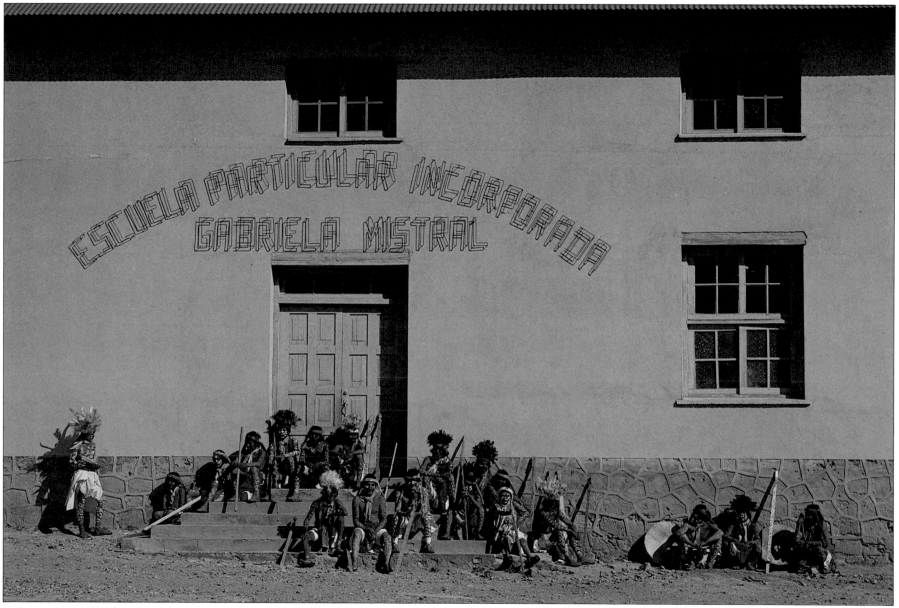

Fariseo    Sierra Tarahumara, Mexico

Good Friday
Sierra Tarahumara, Mexico

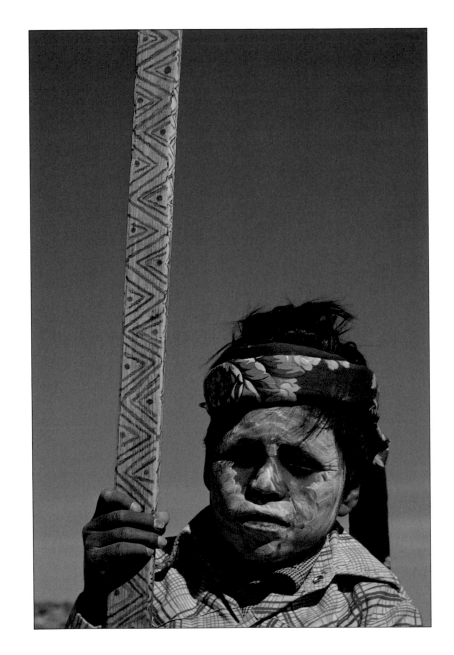

Fariseo
Sierra Tarahumara, Mexico

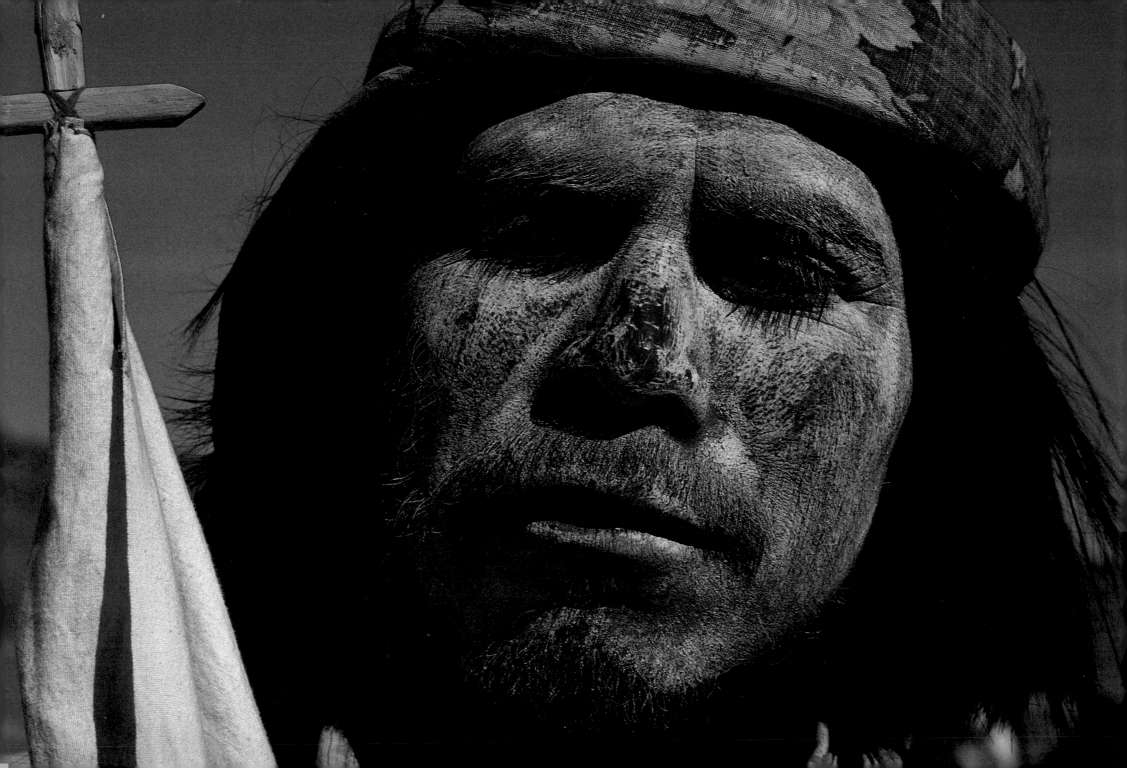

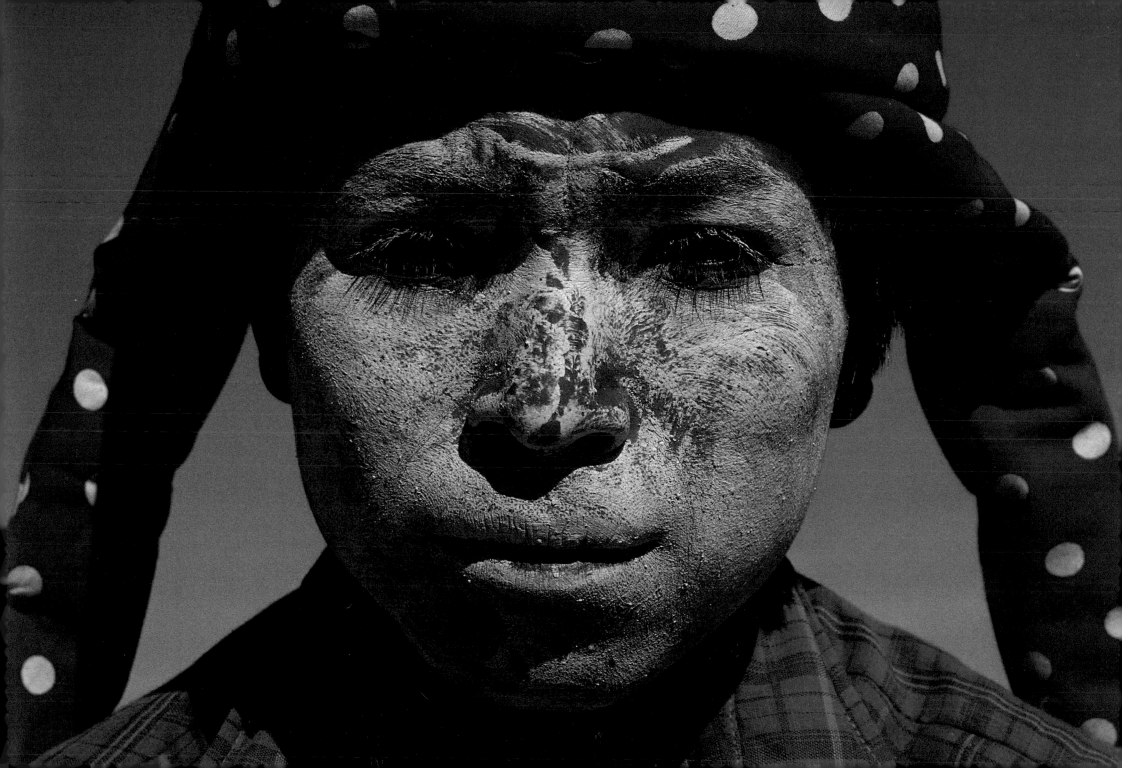

Fariseo
Sierra Tarahumara, Mexico

Good Friday
Sierra Tarahumara, Mexico

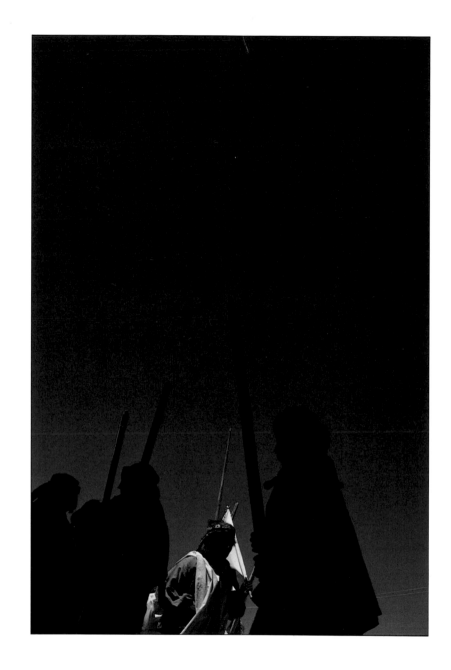

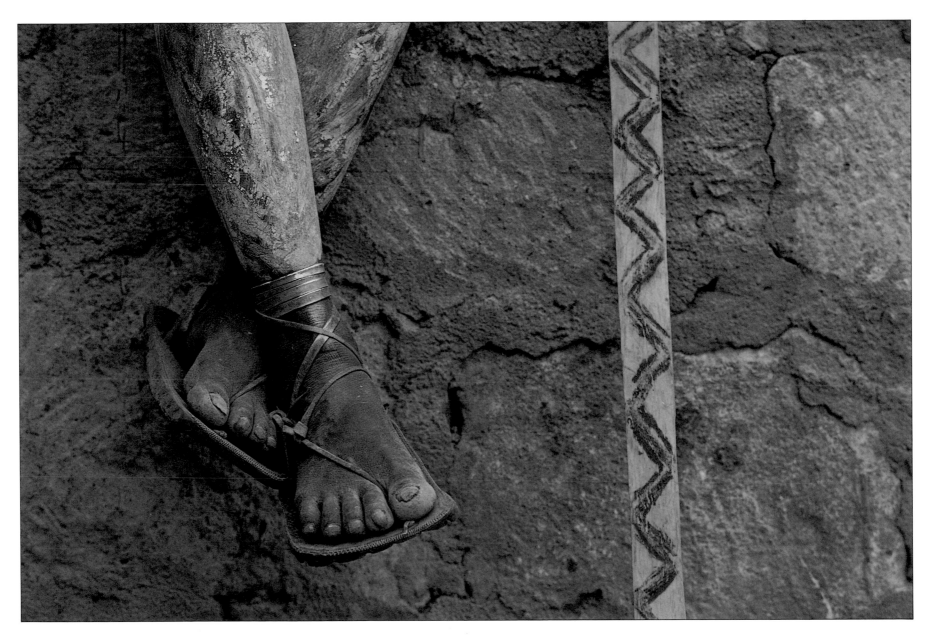

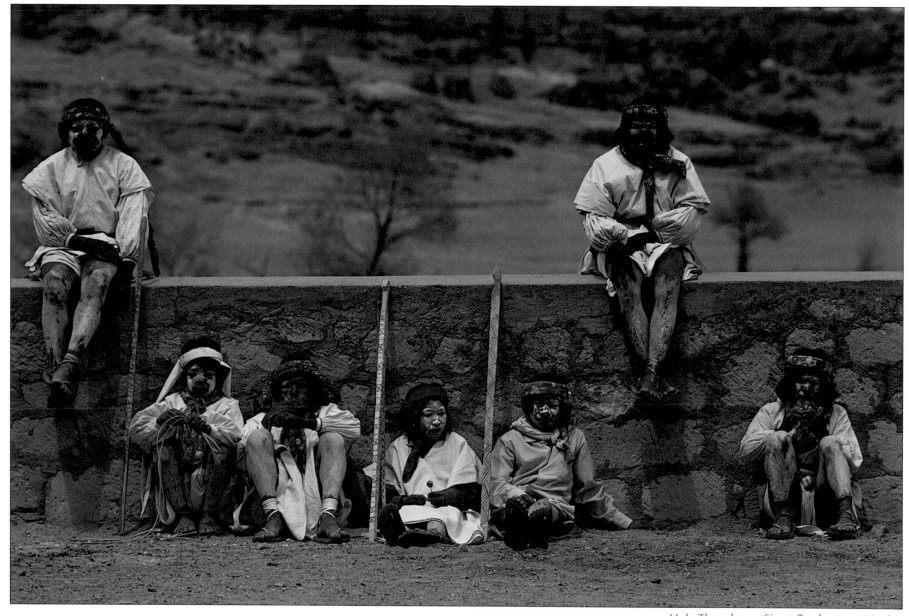

Holy Thursday    Sierra Tarahumara, Mexico

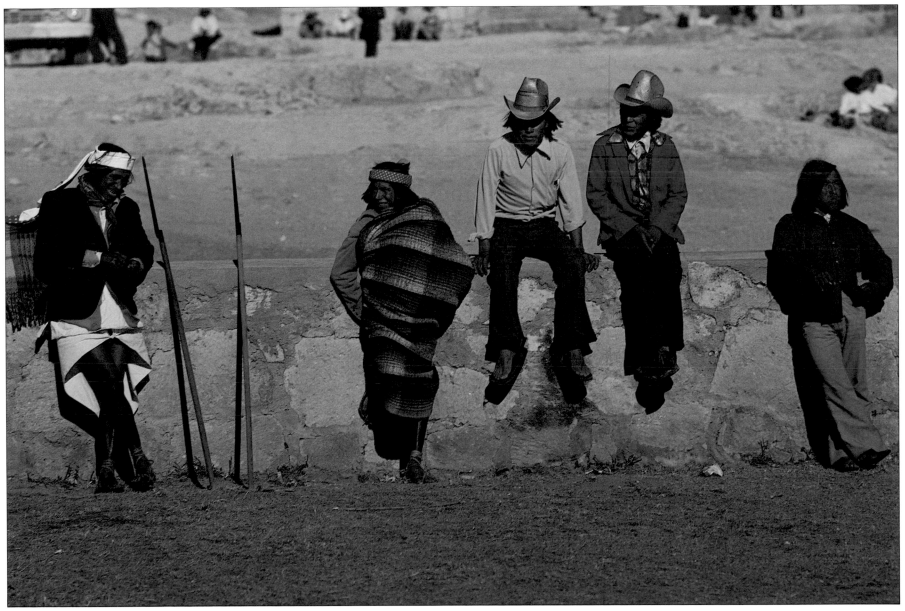

Christmas Eve    Sierra Tarahumara, Mexico

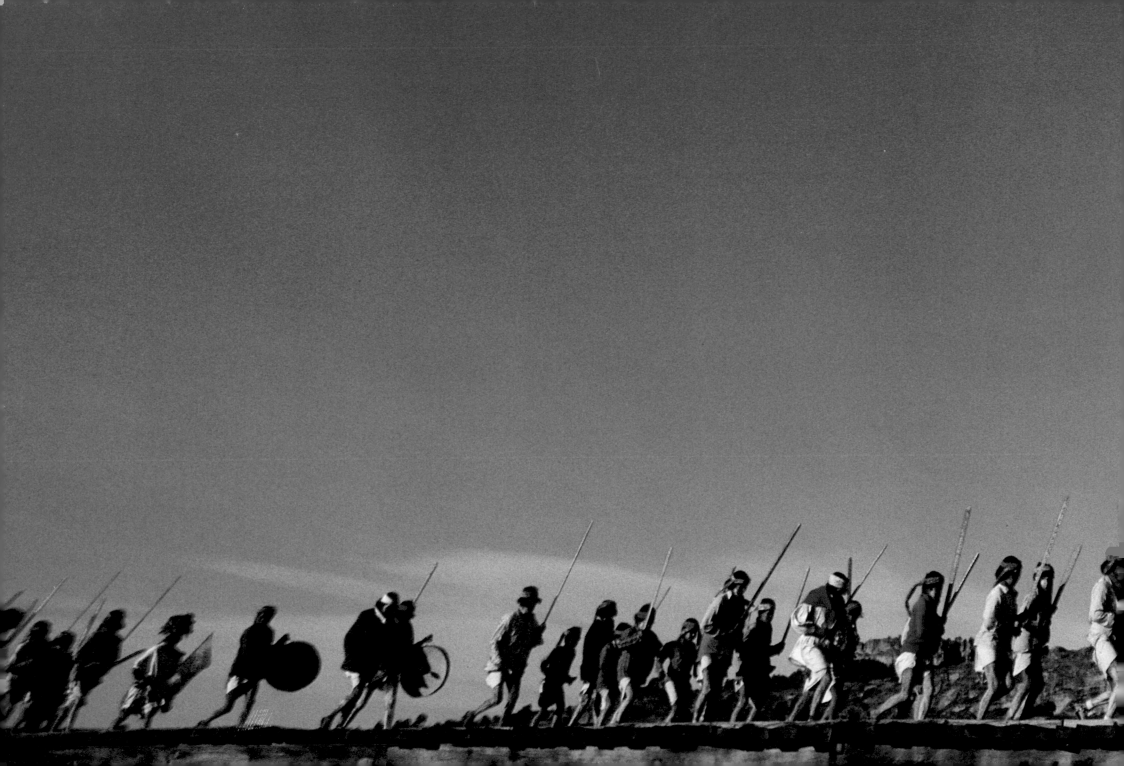

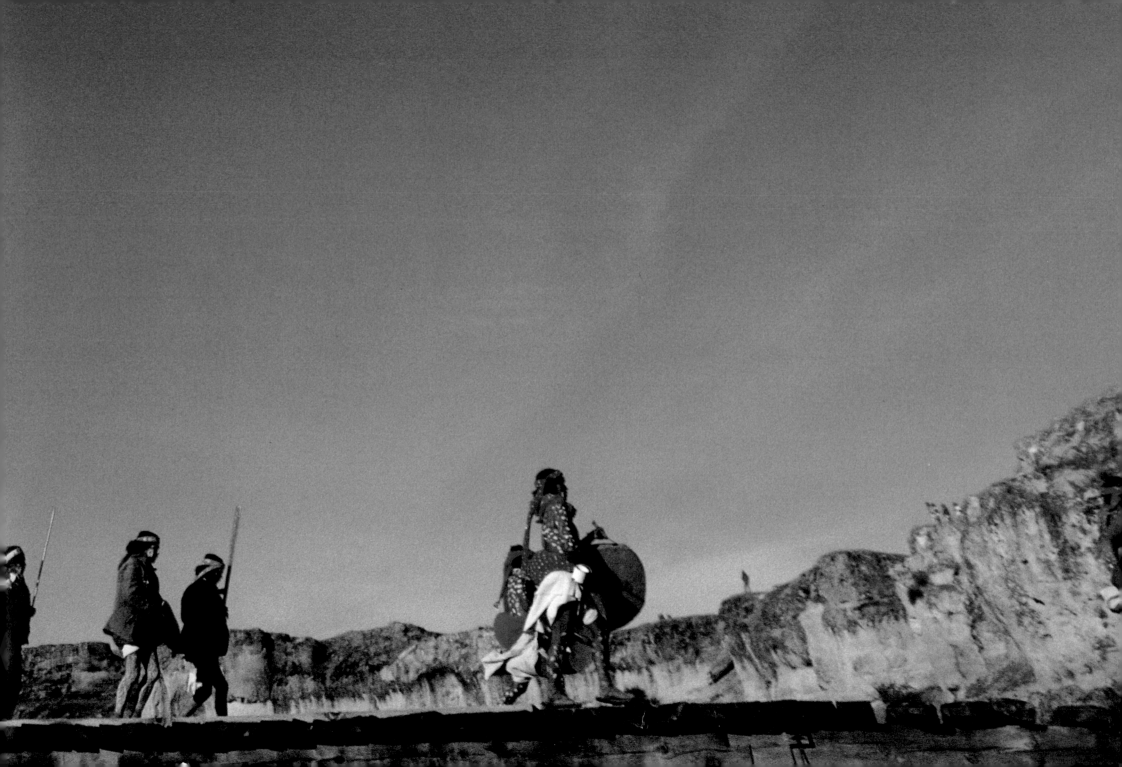

Christmas Eve
Sierra Tarahumara, Mexico

Christmas Week
Sierra Tarahumara, Mexico

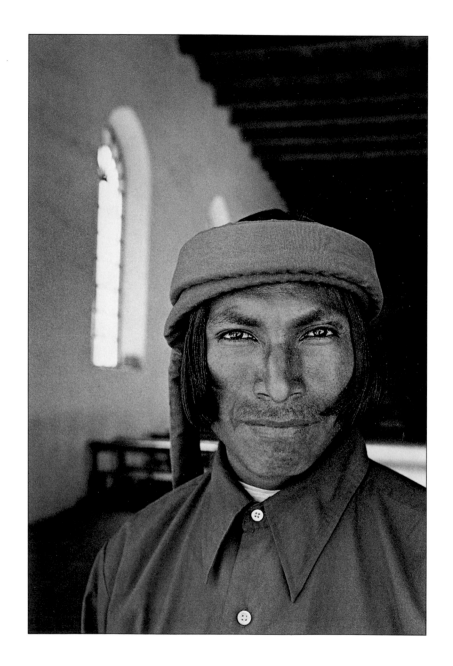

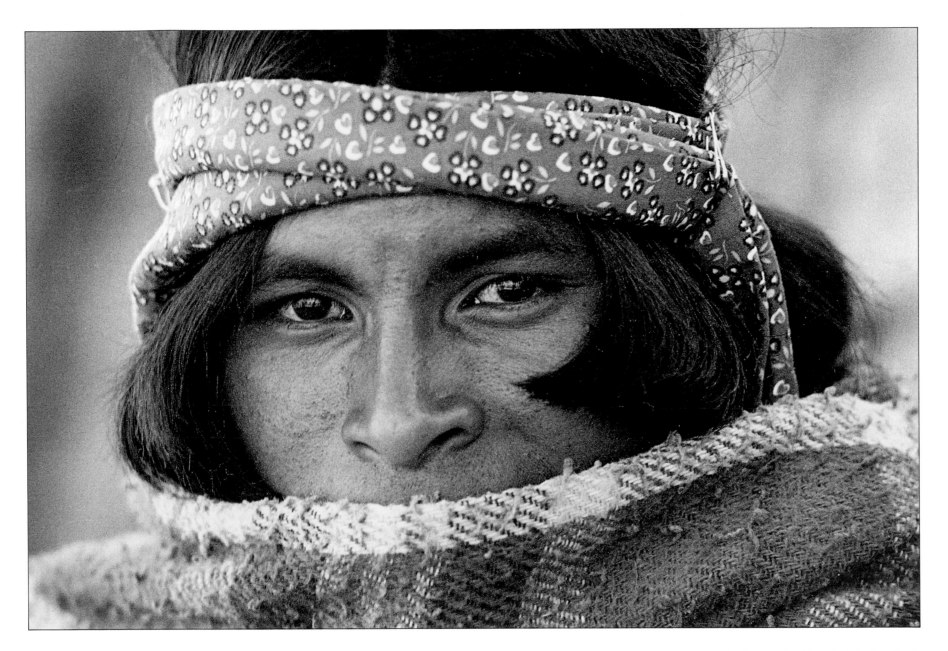

Fariseo
Sierra Tarahumara, Mexico

Christmas Week
Sierra Tarahumara, Mexico

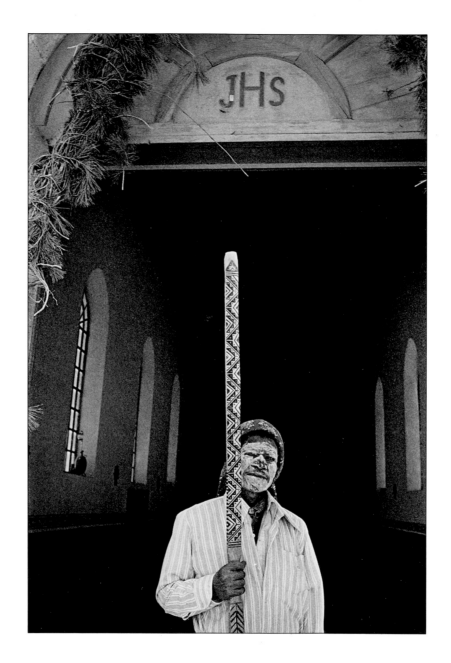

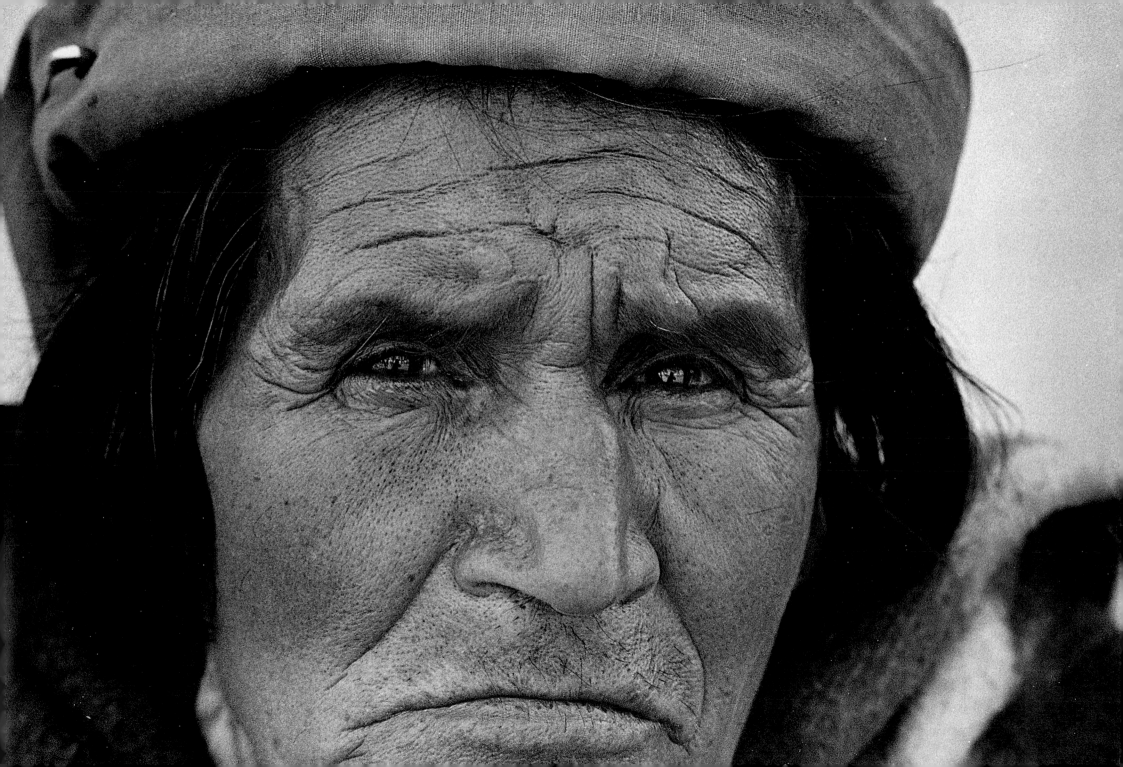

Holy Week
Sierra Tarahumara, Mexico

New Year's Eve
Sierra Tarahumara, Mexico

Holy Week
Sierra Tarahumara, Mexico

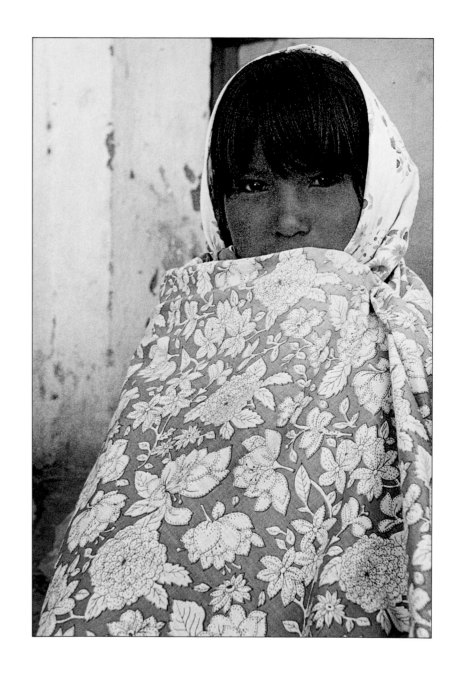

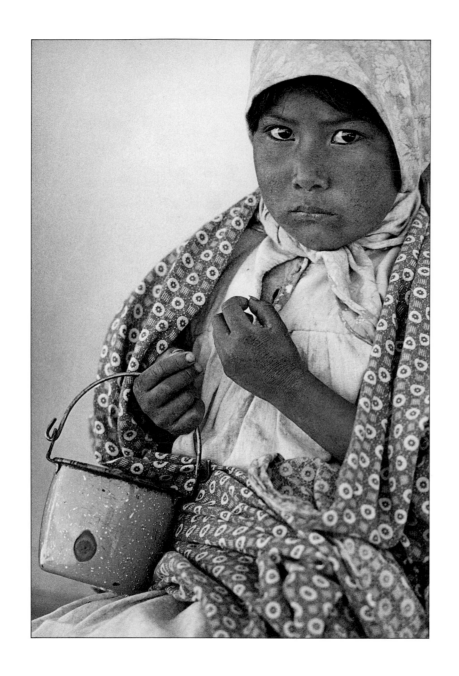
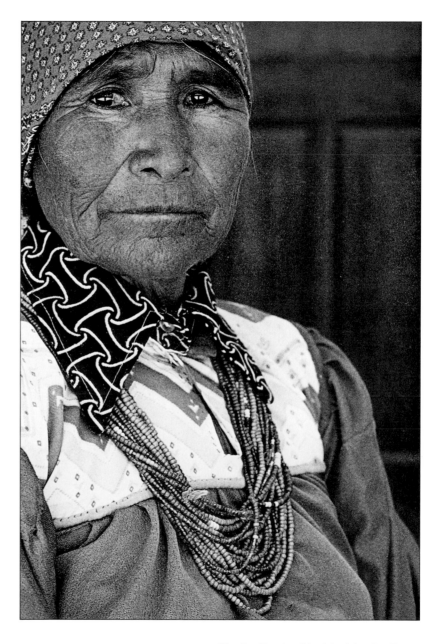

Holy Week
Sierra Tarahumara, Mexico

Holy Week
Sierra Tarahumara, Mexico

Christmas Week
Sierra Tarahumara, Mexico

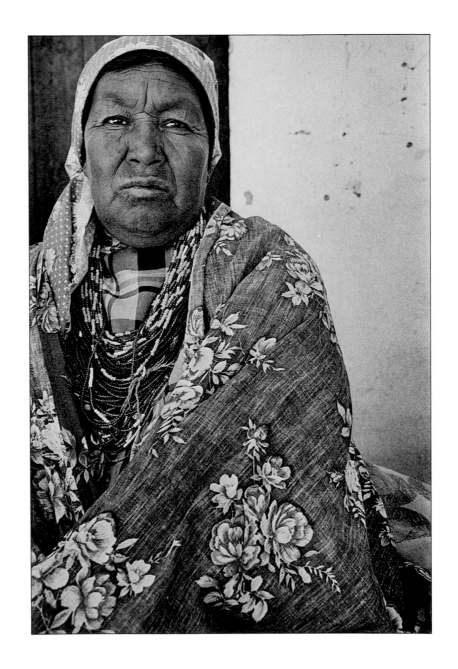

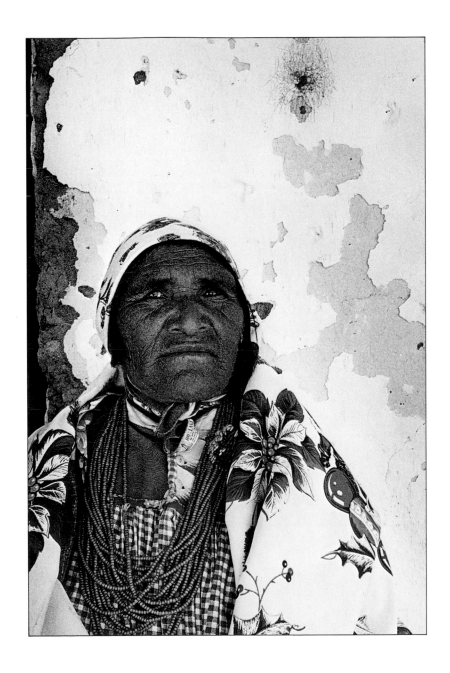

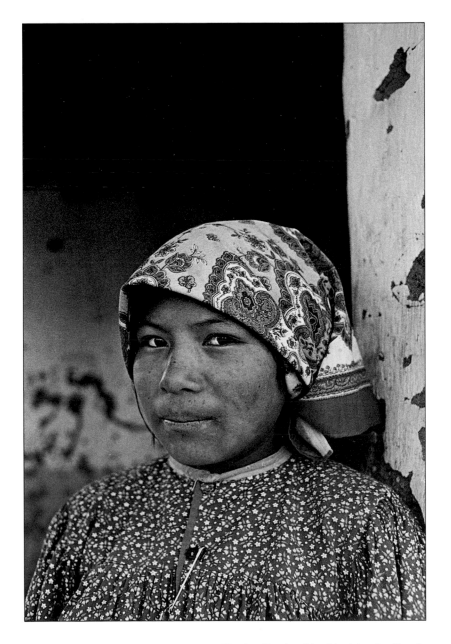

Holy Week
Sierra Tarahumara, Mexico

Holy Week
Sierra Tarahumara, Mexico

Holy Week
Sierra Tarahumara, Mexico

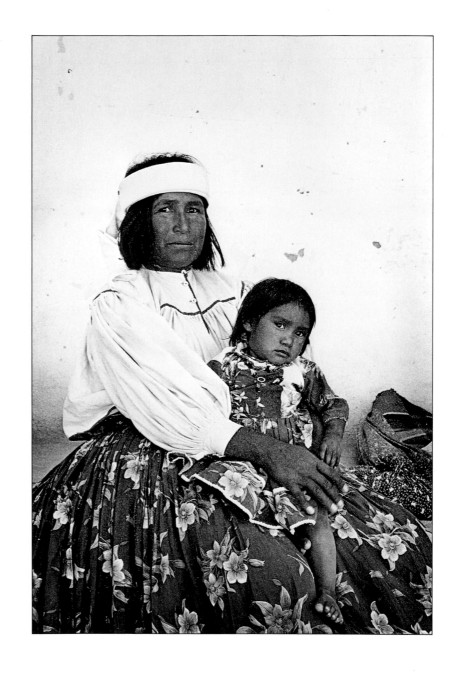

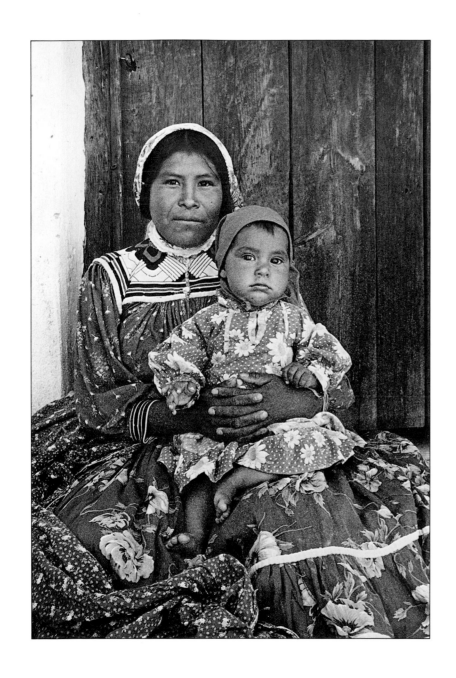

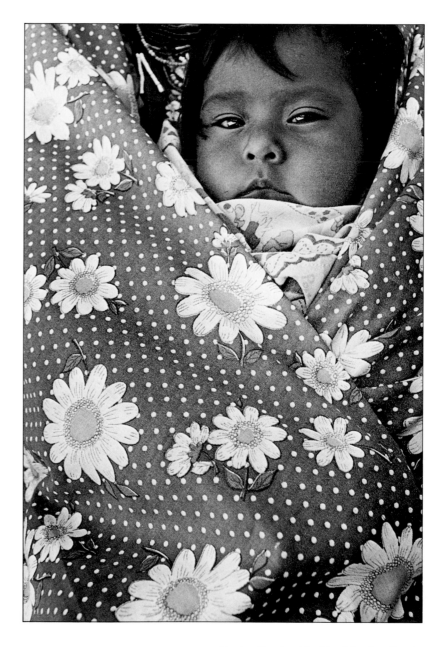

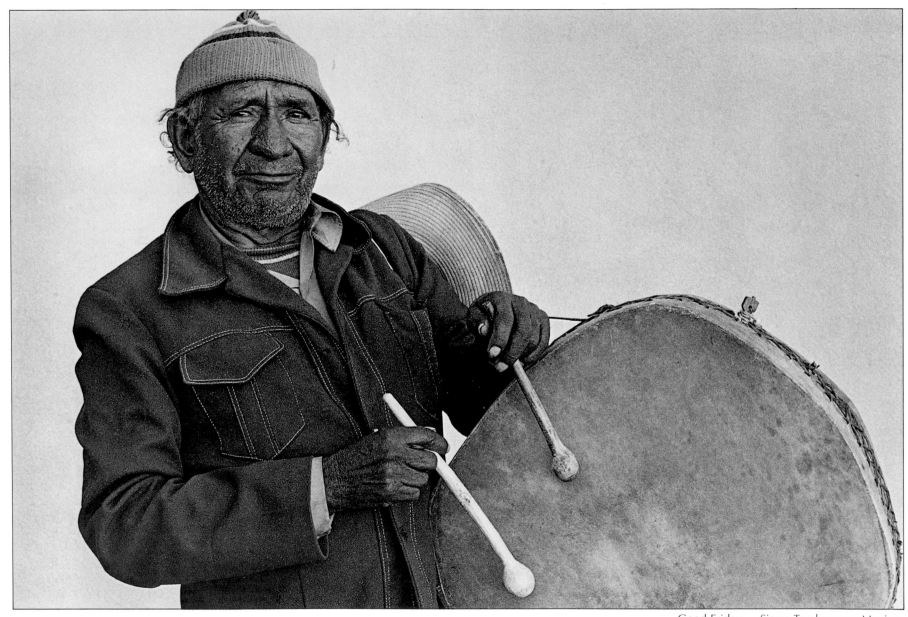

Good Friday    Sierra Tarahumara, Mexico

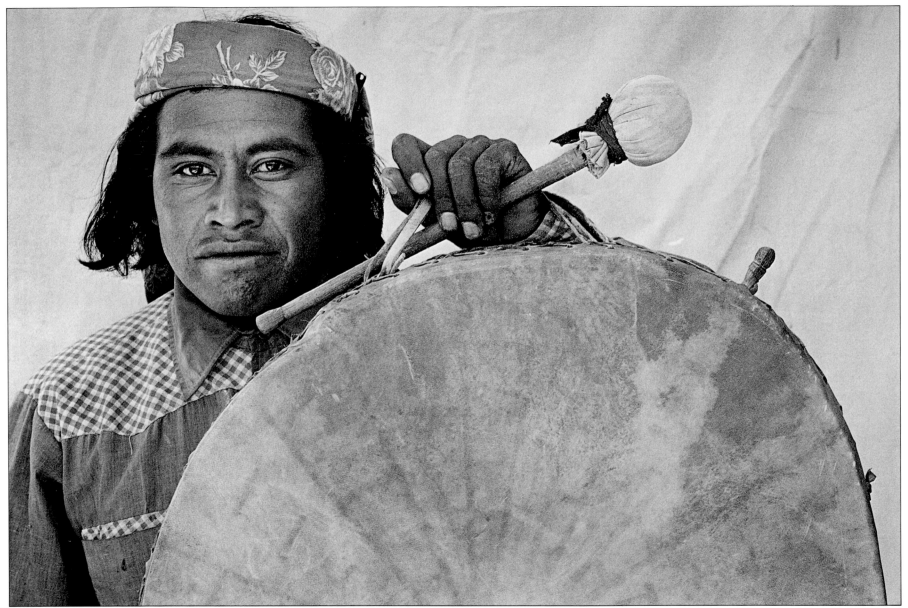

Holy Week    Sierra Tarahumara, Mexico

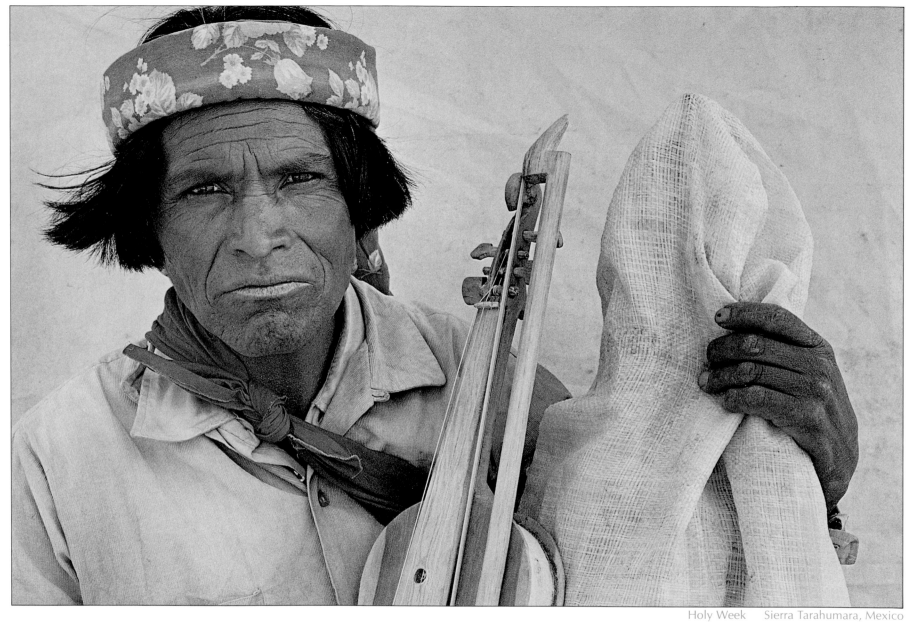

Holy Week      Sierra Tarahumara, Mexico

New Year's Day, 1980      Sierra Tarahumara, Mexico

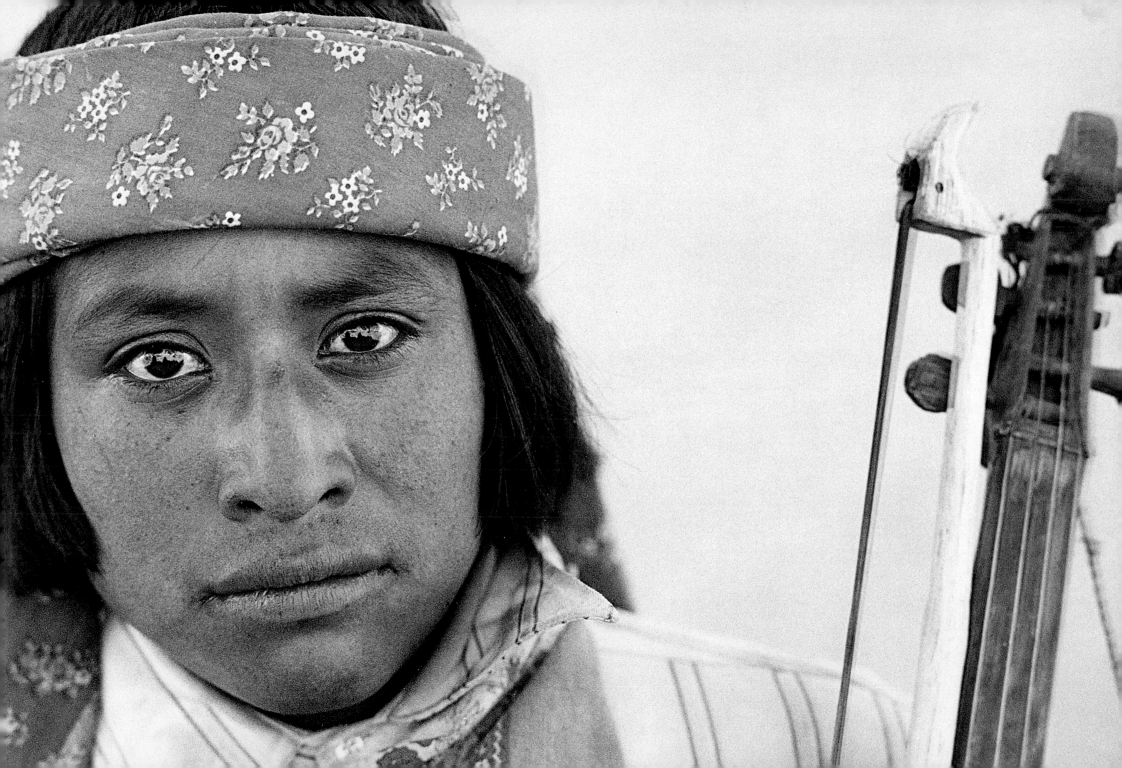

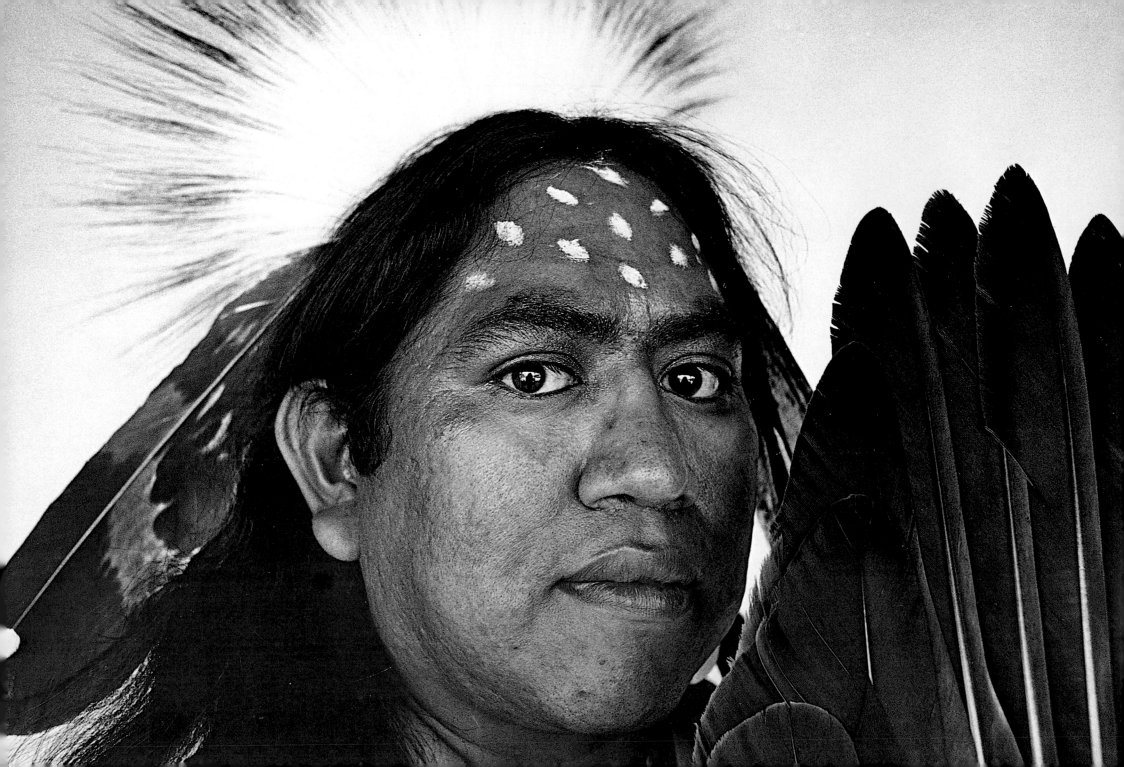

*"Free portraits! Photographer is In!"* The sign was tacked up on a post in front of Dick and Jeri's garage. Dick and Jeri Greeves are both good friends. We had met several years before when I was following the pow-wow circuit, spending a week on the Wind River Reservation. Jeri runs the Fort Washakie Trading Company; Dick makes the best sculptures of Native Americans I have ever seen. They both helped me to understand the pow-wow, gave me good advice, and invited me into their home. Most important, they invited me back. We corresponded and had an opportunity to visit in Arizona, but it wasn't until three years later that I accepted their standing invitation and returned to their trading post and studio and set up a north-light studio in their garage.

*"Free portraits! The photographer is In!"*

This was a dream come true. To have studio space on a reservation. To have people come to me to have their portraits made. Jeri took time from her busy schedule to help me locate people willing to be photographed in exchange for some Polaroid prints. People came, stood in front of my camera and presented themselves to my eye and to my camera. They were involved in the idea of self-presentation.

"Hey John!" Dick Greeves yelled. "Do you want to photograph a real Indian? Leon, I want you to meet John. John, this is Leon. Leon, stand over there and let him take your picture."

Traditional dancer
Shoshone Tribe
Fort Washakie, Wyoming

Shoshone woman
Fort Washakie, Wyoming

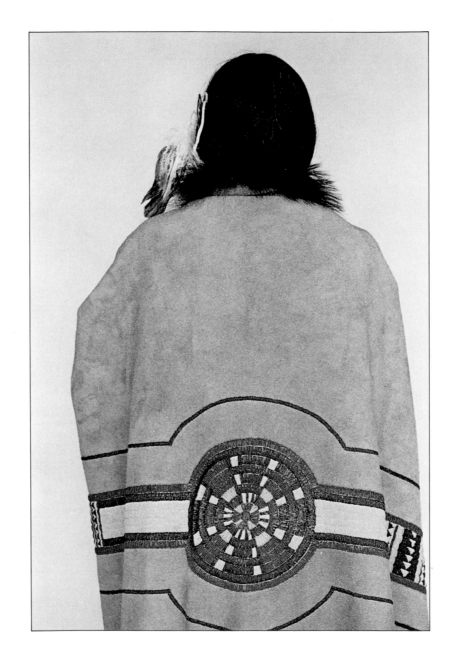

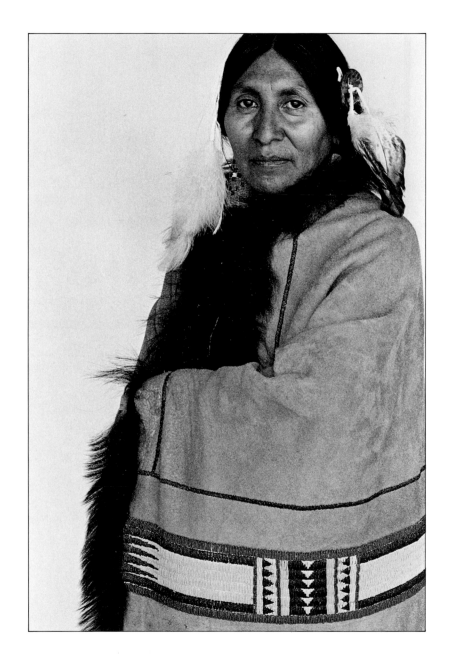

Shoshone woman
Fort Washakie, Wyoming

Young traditional dancer
Shoshone Tribe
Fort Washakie, Wyoming

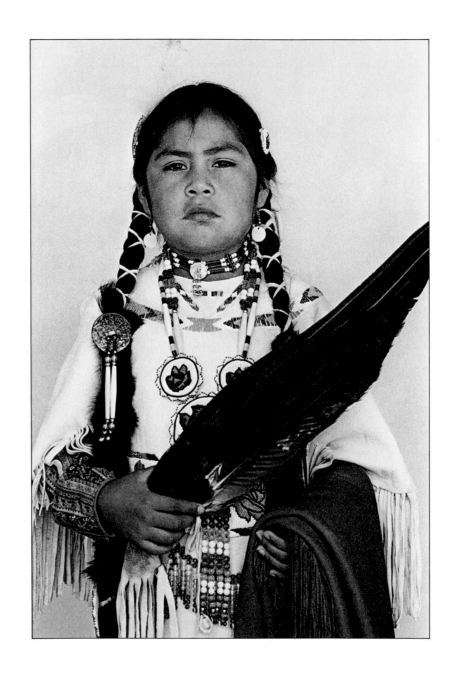

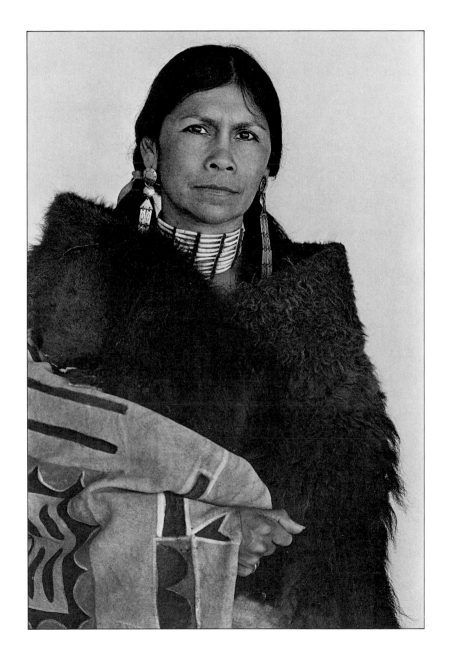

Kiowa/Commanche woman
Fort Washakie, Wyoming

Young traditional dancer
Shoshone Tribe
Fort Washakie, Wyoming

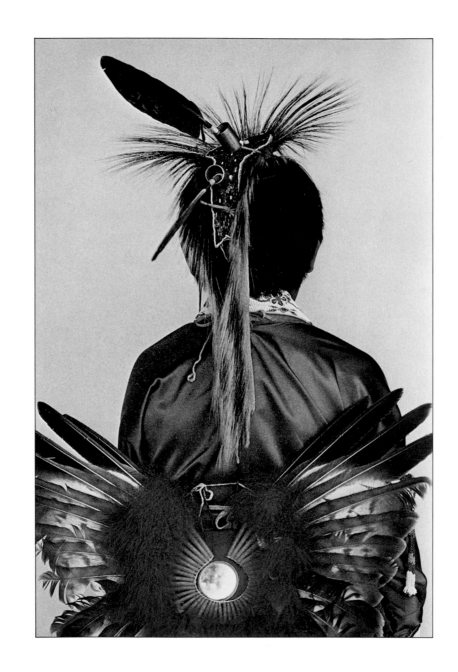

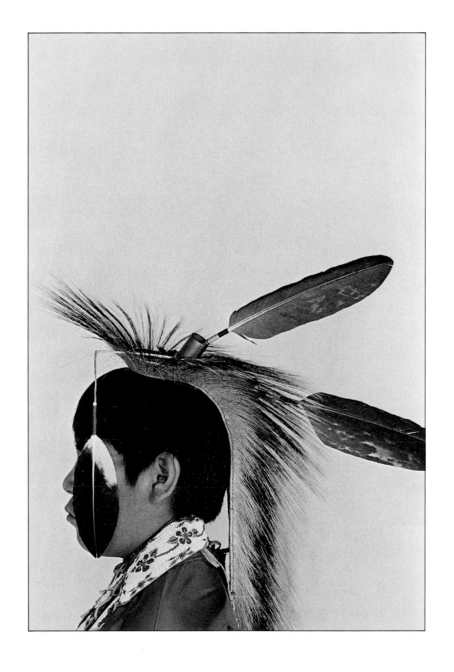

Young traditional dancer
Shoshone Tribe
Fort Washakie, Wyoming

Shoshone girl
Fort Washakie, Wyoming

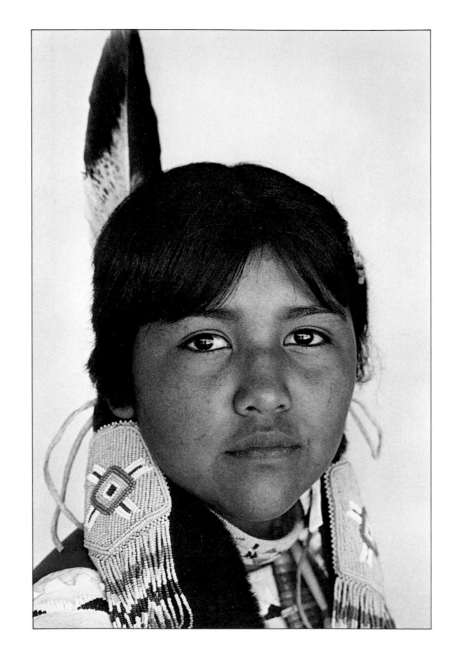

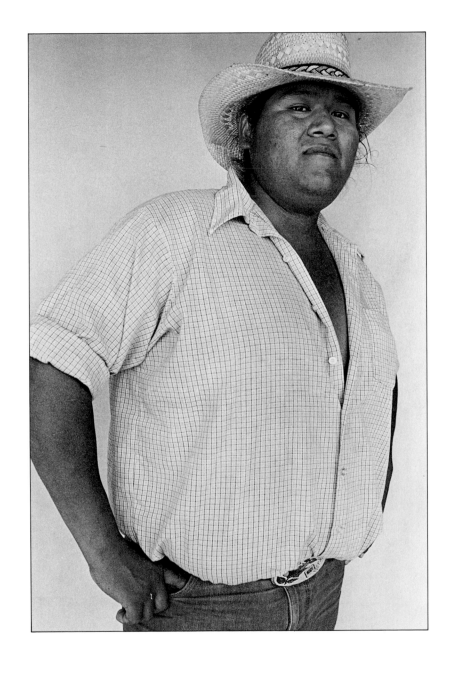

Leon
Shoshone Tribe
Fort Washakie, Wyoming

Shoshone woman
Fort Washakie, Wyoming

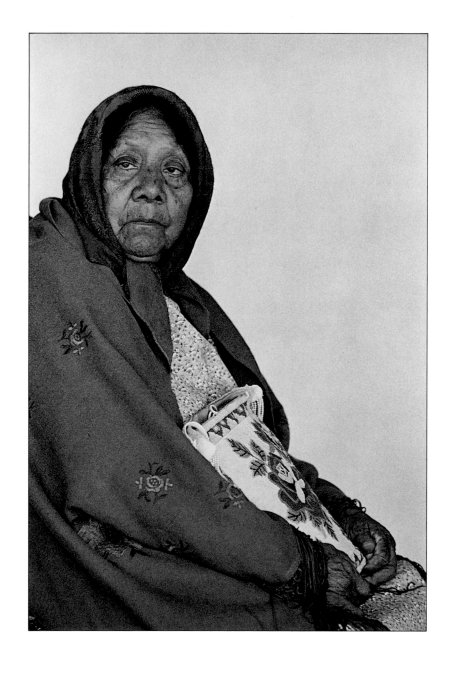

Shoshone woman
Fort Washakie, Wyoming

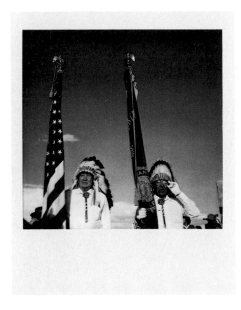

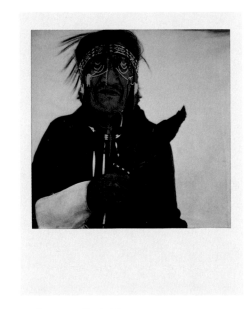

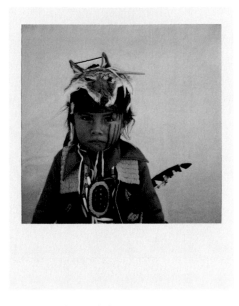

Flag Honor Guard
Blackfeet Tribe
Browning, Montana

Andrew Wolf Child
Blood Tribe
Stand Off, Alberta

Young traditional dancer
Lakota Tribe
Fort Berthold, North Dakota

His name was Solomon, a fisherman living halfway up the east coast of the peninsula of Baja California. I was exploring a miles-long beach. A small path through palm trees led me off the beach, past a corn field to a little ranchería. Beauty and curiosity led me on. A tall man in his fifties left the shade of the little house and waved to me. "Quieres agua?" he asked. "Sí, por favor," I replied. We exchanged greetings and returned to the shade to visit. The light was beautiful, warmed by the hot sun reflected off reddish earth to open up the shadows in our cool shade.

I wanted to make pictures of Solomon and his wife Anastacia. She looked down shyly, and he nodded when I asked permission. First I took some instant pictures with a Polaroid SX-70 camera, then got out my 35mm camera while the "loids" were developing. Solomon and Anastacia sat there patiently while I worked. I motioned for them to move one way or another, bring a hand up on the arm of a chair, tilt a head up or down. "Would you mind moving over by the door?" "Qué bonita! That's beautiful!" We hardly talked at all during the time I shot several rolls of film.

We looked at the *instantáneas*. Anastacia thought they were beautiful *recuerdos*. I told them that they were for them to keep. Solomon thanked me and told me they had nothing to give me, when Anastacia went into the house and came out with a

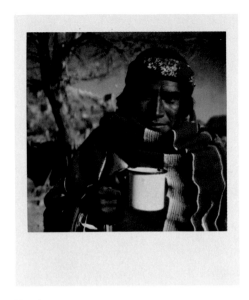

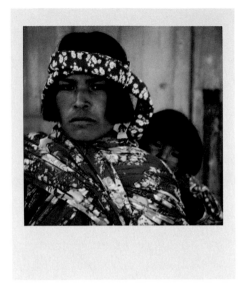

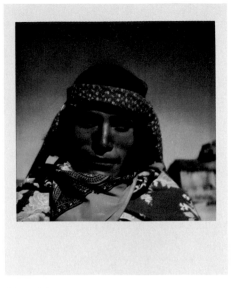

goat cheese about the size of two clasped hands. "Here, this is for you."

We all sensed that next awkward moment, the time to say adiós. I had to meet the people I was traveling with back on the beach. I started to say goodbye when Solomon interrupted, "*Momentito*. A little minute, before you go. Let me take your picture with the *instantánea*. You are taking part of us with you. You should leave something of yourself behind with us. We want to remember you, too."

Solomon took the camera in his fisherman hands, pressed the little red button to make his pictures, telling me to sit there, motioning me to raise or lower my chin. He made sev-

eral exposures. We waited for them to develop, and then we agreed that I looked very good before he slipped them into his shirt pocket. I held Anastacia's hands for a moment, embraced Solomon, turned from the shade and headed down the path, through the palms, and back to the beach. On my way I thought about how lucky I was to be able to travel, how fortunate I was to meet people like Solomon and Anastacia. How I was the recipient of the most personal of all gifts when people answered, "Yes," to my question, "Would you let me make your picture?"

I also thought about the lesson Solomon, the wise fisherman, had just given me, "Leave part of yourself behind." When I make pictures, I try to open myself up to the person I photograph. I

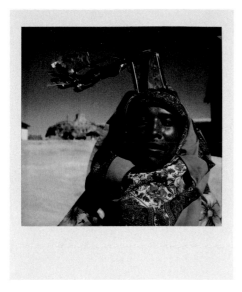

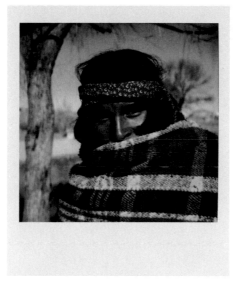

Matachine
Sierra Tarahumara, Mexico, 1980

Tarahumara man
Sierra Tarahumara, Mexico, 1980

try to make an exchange. It is necessary if my pictures are going to work at all. It is absolutely necessary. I have to leave something of myself behind.

I have given Polaroid pictures away all over the world. Sometimes when I make an exceptionally beautiful "loid" I am tempted to keep it. If I have enough film I'll make two or three and then let the people choose which ones they want to keep. Most pick the best. The Tarahumara invariably choose the best. Sometimes I hate to let them go. But I console myself knowing I have my film, I have their gift rolled up in a little cassette. Occasionally, people ask me if they can take my picture, and I think of Solomon and remember. Leaving my picture with the people I photograph is not as important as leaving my spirit with them. Solomon and I communicated with each other, shared our feelings and exchanged our humanity. He taught me to make the same exchange with everyone I photograph.

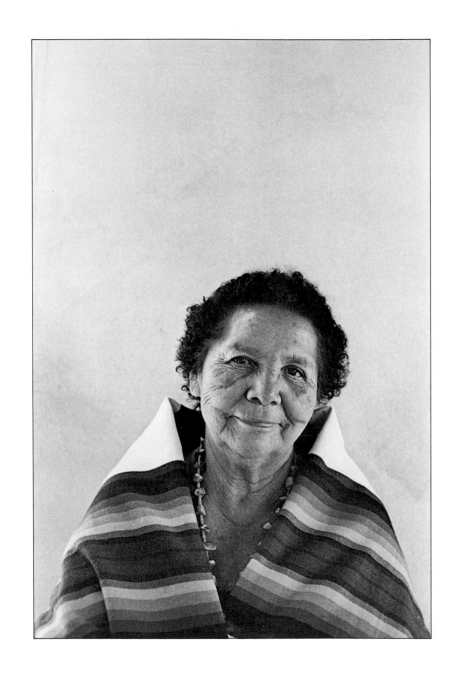

Nina is a medicine woman; she carries a sacred medicine bundle of the Kiowa Tribe. One morning she prayed for a sick friend inside a tipi at the Arapahoe Sun Dance camp. She prayed, then placed the medicine bundle on the man and told him to stay inside the tipi for a while. Afterward, she and I started breakfast over an open campfire—she cooked bacon, I fried potatoes. Later, the man Nina had prayed for left the tipi, approached her at the cooking fire and thanked her. She looked up from her bacon, wiped sweat off her forehead with her wrist and replied in her Oklahoma drawl, "Oh, you don't have to thank me. That's what I'm for." Nina carries the sacred medicine bundle and its responsibility. She looks like so many Indian women. She is Indian Woman. Nina, pray for me.

Nina
Kiowa Tribe
Fort Washakie, Wyoming

Published by the University of Nevada Press, *Honor Dance* was printed by Paragon Press, Salt Lake City, Utah. The typeface is Linotron 202 Optima Light, derived from Optima which was designed for hot metal composition by Hermann Zapf between 1952 and 1955 for the D. Stempel AG Foundry, and first issued in Linotype in 1958. Composition was supplied by G & S Typesetters, Inc., Austin, Texas. This book was printed in seven colors with spot varnish using a 28 × 40 inch Akiyama offset sheetfed lithographic press on 100 lb. S. D. Warren Cameo Dull stock. The binding was executed by the Hiller Industries Bindery, Salt Lake City, Utah. Production supervision by Rick Stetter, Bob Petersen, and Steve Renick; editing by Scott Thybony and Nick Cady.

Book design by Steve Renick, Anselm Design, San Anselmo, California.